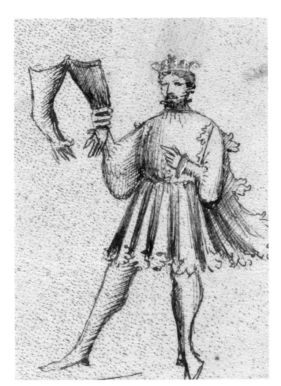

THE KNIGHTLY ART OF BATTLE

KEN MONDSCHEIN

THE KNIGHTLY

THE J. PAUL GETTY MUSEUM

LOS ANGELES

ART OF BATTLE

© 2011 J. Paul Getty Trust
Published by the J. Paul Getty Museum

Getty Publications
1200 Getty Center Drive, Suite 500
Los Angeles, CA 90049–1682
www.gettypublications.org

Beatrice Hohenegger, *Editor*
Kurt Hauser, *Designer*
Stacy Miyagawa, *Production Coordinator*

Printed in Singapore

Illustrations
All illustrations in this book are from the
illuminated manuscript *Fior di battaglia*
by Fiore dei Liberi in the collection of the
J. Paul Getty Museum. Ms. Ludwig XV
13 (83.MR.183), Northern Italy, ca. 1410.

Page 1: *Four Allegorical Figures* (detail),
fol. 10.
Pages 2–3: *Equestrian Combat with
Lance and Sword* (detail), fol. 42v.
Page 5: *Combat with Dagger* (detail),
fol. 17v.

Author's Acknowledgments
I would like to thank Jeffrey Forgeng,
Arthur Kinney and the staff at the Center
for Renaissance Studies at the University
of Massachusetts Amherst, Tom Leoni,
Greg Mele, Paul Sise, and all my teachers
and students. This book is dedicated to
my grandfather, Albert Krantzberg.

Disclaimer
Readers should not attempt to re-
create any fighting position or handle
any weapon based on the information
provided in this book. Neither the author
nor the J. Paul Getty Trust accepts
responsibility for the consequences of
any use or misuse of the following texts
and illustrations.

CONTENTS

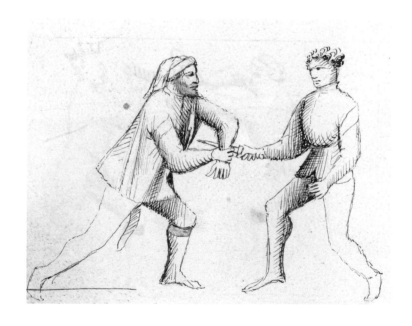

FOREWORD

Sought out by art historians for its dynamic fifteenth-century
pen drawings, studied by historians as evidence of Italian court
culture, and treasured by martial arts enthusiasts eager to under-
stand Renaissance techniques, the Getty's copy of Fiore dei Liberi's
Fior di battaglia (Ms. Ludwig XV 13) has consistently attracted
attention since its acquisition in 1983. The manuscript was owned
over the course of its history by a series of well-known collec-
tors, including the powerful doge of Venice, Niccolò Marcello (ca.
1399–1474); the Venetian poet and man of letters Apostolo Zeno
(1668–1750); Luigi Celotti (ca.1789–ca.1846), infamous for cutting
individual images out of manuscripts (although thankfully not in
this case); the English antiquarian Thomas Phillipps (1792–1872);
and Peter and Irene Ludwig, of Aachen, Germany, who assembled
the finest private collection of illuminated manuscripts of the later
twentieth century. This wonderful manuscript is now, for the first
time in its history, in a public institution, where tens of thousands
of visitors over the past decades have had a chance to discover it.

I thank scholar Ken Mondschein, who is a research fellow
at the Higgins Armory Museum in Worcester, Massachusetts,
and teaches at American International College in Springfield,
Massachusetts, for exploring this extraordinary manuscript for
the first time in a dedicated publication in English. I am grateful
for his deep understanding of martial arts in the Renaissance as
well as for his enthusiasm for making Fiore's text and illustrations
intelligible to a large and interested audience. I am grateful to
Gregory Britton, former head of Getty Publications, who originally
proposed this wonderful project, having been inspired by seeing
the manuscript. In the Publications department, I would also like

to recognize designer Kurt Hauser, who has an extraordinary ability to bring manuscripts to life on the pages of our publications, and Beatrice Hohenegger and Stacy Miyagawa, who saw the book through a series of tight deadlines. For the photography, I recognize the efforts of Rebecca Vera-Martinez and Johana Herrera in making the digital images sparkle. For the handling of the manuscript my thanks go to Christine Sciacca and Stephen Heer.

I am delighted that this publication will enable enthusiasts and scholars alike to enjoy the Getty's *Fior di battaglia*, a spectacular and unique testament to Italian fifteenth-century culture and art.

Elizabeth Morrison
Acting Senior Curator of Manuscripts
The J. Paul Getty Museum

Furlan de Ci
uida d'ostria
che fo di miss
Benedetto de
la nobel casada
deli liberi da
Premeryas de
la dyoce si dllo
patriarchado
de Aquilegia
in sua couentu
uolse inprender ad armizare
l'arte de combatter i sbarra.
E de lanca acça, spada e da
ga, e de abracare a pe e a caual
lo, in arme e senca arme.
E anchora uolse sauere tempere
di ferri. E fatece d'caschuna
arma tanto a deffender quanto
ad offendere; e maxima mente
chose de combatter a oltranca.
E anchora altre chose merueeglose
e oculte le quale a pochi homini
del mondo sono palese. E sono
chose uerissime e d' grandissima
offesa, e de grande deffesa, e chose
che nō se po fallare tanto sono
ligie a fare. E la quale arte e
magisterio che ditto di sopra
E lo ditto fiore sia imprese le
ditte chose da molti magistri
todeschi e di molti italiani
in piu prouince e i molte citad
cū grandissima e cū grand spese.
E p la graua di dio da tuti mi
gistri e scolari. E i corte di
grandi signori, principi duchi
marchesi e conti chaualieri e
schudieri in tanto a ipresa qsta
arte. E che lo ditto fiore a stado
piu e piu uolte richesto da molti
signori e chaualieri e schudieri
p imprender del ditto fiore si fatta
arte d'armizare e d' cōbatter i sbarra
a oltranca la quale arte ello a mon
strada a piusibi ytaliani e todeschi
y altri grandi signori che ano de
buto combattere in sbarra. E
ancho ad infiniti che non ano debu
do combattere. E de alcuni che

sono stadi miei scolari che ano d'buto
cōbatter in sbarra. E de quali alchuni
qui ne faro nome e memoria. E pmo
de loro si fo el nobele e gagliardo cha
ualiero misser piero del uerde, el qle
debea combattere cū misser piero
d' la corona iquali forono ambi doy
todeschi. E la batuglia debea esser
a perosa. E anchora alo ualoroso
chaualiero misser nicolo Vriciano
thodesco che debea cōbutere cū nicolo
Inghileso. Lo campo fo dado ad jmola.
E anchora al notebele ualoroso e
gagliardo chaualiero misse baleaço
di captani di grimello chiamado di
Mantua che debea cōbattere cū lo ua
loroso chaualiero misser Buçichar
do de fraça. Lo campo fo a padua.
E anchora al ualoroso schudiero Lan
celotto da Becharia de pauia el qle
se p. vj. punti de lanca a ferri mola
di a chauallo, contra lo ualente ca
ualiero misser Baldassaro todesho.
I quali ad ymola debea cōbatter in
sbarra. E anchora al ualoroso
schudiero Coanino da Bayo da mi
lano che se in pauia in lo castello
contra lo ualente Schudiero Sram
todesco tre punti di lanca a ferri
moladi a chauallo. E poy se a pe
tre colpi d'acça, e tre colpi d'spada
e tre colpi di daga i presenca del
nobilissmo pncipo e signore mis
ser lo Ducha di milano e d' madona
la duchessa, e d'altri infiniti signo
ri e donne. E anchora al caute
loso chaualiero misser Açço da
Castell Barcho che debea un'a uolta
cōbatter cū Çuanne di ordelaffi.
E un altra uolta cū lo ualente
e bōy chaualiero misser Jacomo
da Boson, el campo debea esser al
piasere delo signore ducha di mi
lano. Di questi e d'altri iquali io
fiore o magistrudi io soy molto
contento p che io son stado ben rimu
nerito e o habudo lo nore e l'amore
di miei scolari e di parenti loro.
E digo anchora che questa arte io lo
mostrada sempre oculta mente
si che nō gle sta presente alchuno

INTRODUCTION

Far from uneducated brutes who relied on strength over skill, knightly combatants in the Middle Ages were experts in sophisticated and subtle martial arts that could be used in a variety of situations—friendly bouting, tournaments (in which participants could display their status and wealth as well as fighting prowess), feudal warfare in service of one's prince, judicial duels fought for life and honor, and self-defense against an assassination attempt or sudden ambush. These were not separate spheres of activity but all equally important to the business of being noble. The male upper class in the medieval period defined itself by the profession of arms, and to be a true member of the elite was to be proficient in these skills.

Among the hundreds of fencing or fighting books, or *Fechtbücher*, documenting the tricks of this trade, Fiore dei Liberi's ca. 1410 masterwork *The Flower of Battle* (*Fior di battaglia*) stands out not only as one of the earliest but also as one of the few examples from Italy. Also known by its Latin title, *Flos Duellatorum*, it is a priceless document of medieval arms, armor, and fighting techniques—and the first surviving work in the genre to be written in Italian. It is thus an invaluable witness to the place of the training in arms in the birthplace of the Renaissance. Four copies are known: one owned by the J. Paul Getty Museum in Los Angeles (Ms. Ludwig XV 13); one residing at the Morgan Library in New York (Ms. M.383); one, known as the Pisani-Dossi manuscript, in private hands; and a slightly later copy, the only example in Latin, in the Bibliothèque nationale de France in Paris (Ms. lat. 11269). Two additional copies are now lost but were attested as being in the library of the d'Este family of Ferrara.

The opening page to the Getty manuscript with Fiore's prologue and dedication to Niccolò d'Este. (fol. 1)

Of the four surviving manuscripts, the Getty copy is not only the most complete but by far the finest. Aside from its artistic merit, however, the unusual nature of the Getty copy of *The Flower of Battle* cannot be overemphasized. Most medieval masters-at-arms (professional martial arts instructors) labored in obscurity and left no record of their teachings. Only two *Fechtbücher* older than Fiore's work exist, both originating in what is now Germany. One of these is a beautifully illustrated manuscript known as the Royal Armouries Manuscript I.33, composed in about 1320 and currently residing at the Royal Armouries in Leeds. It depicts, in a typically flat, stylized medieval manner, students, a priest, and a woman named Walpurgis fencing with swords and bucklers. The other is a personal notebook without illustrations, dated 1389 and known as the Nuremberg Codex 3227a, held by the National Museum of Germany in Nuremberg. It records the cryptic teachings of the master Johannes Liechtenauer and several others. Both of these works were clearly intended for a small circle of initiates and are difficult for modern readers to understand. Yet, only two decades later, Fiore dei Liberi created a work filled with naturalistic art that intended to explain clearly a complete system of martial arts— a work meant to survive its author and serve as an unambiguous record of his teachings. The unique nature of *The Flower of Battle* results in part from the particular circumstances of Fiore's life and times.

Fiore dei Liberi

Fiore dei Liberi was born in the region of present-day northeastern Italy known as Friuli. The way in which Fiore introduces himself in the Getty manuscript, "Fiore the Friulian from Cividale of Austria, son of Benedetto of the noble house of Liberi of Premariacco, in the diocese of the Patriarch of Aquileia," reflects the confused political situation of the time. Friuli was the center-piece of several parties' overlapping dynastic claims in a landscape

composed of small, independent cities and principalities, often competing against one another for land and power.

No record has been found of Fiore's father, Benedetto, but his family name, dei Liberi (of the free), might indicate that his ancestors came originally from the class of "free" knights, as opposed to those who were legally bound to their lords—a unique legal situation that only existed in German-speaking lands. Added to this complicated background is the fact that Fiore boasts in the Pisani-Dossi manuscript that he studied with a master named Johannes "called Suveno," that is, from Swabia in present-day Germany. Thus, even though Fiore wrote in Italian, we must see his work as part of the larger cultural heritage of Europe.

Fiore also explains in the introduction to the Pisani-Dossi manuscript that he was inclined toward the profession of arms from an early age and, at the time he wrote in ca. 1410, had been practicing for fifty years. If, like other nobly born youths, Fiore had taken up his sword around the age of ten, this would place his birth date at about 1350. This was a dangerous time in which to be born: Friuli at around the time of Fiore's birth had been badly affected by the Black Death as well as a terrible earthquake. War raged between the kings of France and England; in times of peace, mercenary bands sought employment in Italy, where war was fought not by feudal knights who gave military service in return for land but by professional mercenaries known as *condottieri*. Many of these blades-for-hire found employment in a civil war that broke out in Friuli in 1381. The war was certainly an opportunity for Fiore: he is recorded as being commissioned to inspect and repair the crossbows and siege engines of the city arsenal of Udine, to undertake diplomatic missions, and to pacify and restore order to a countryside ravaged by war. Fiore was clearly as adept as a diplomat, magistrate, and peace officer as he was as a fencing master.

Fiore's activities both before the war and after its conclusion in 1389 are more difficult to reconstruct. Most of what we know

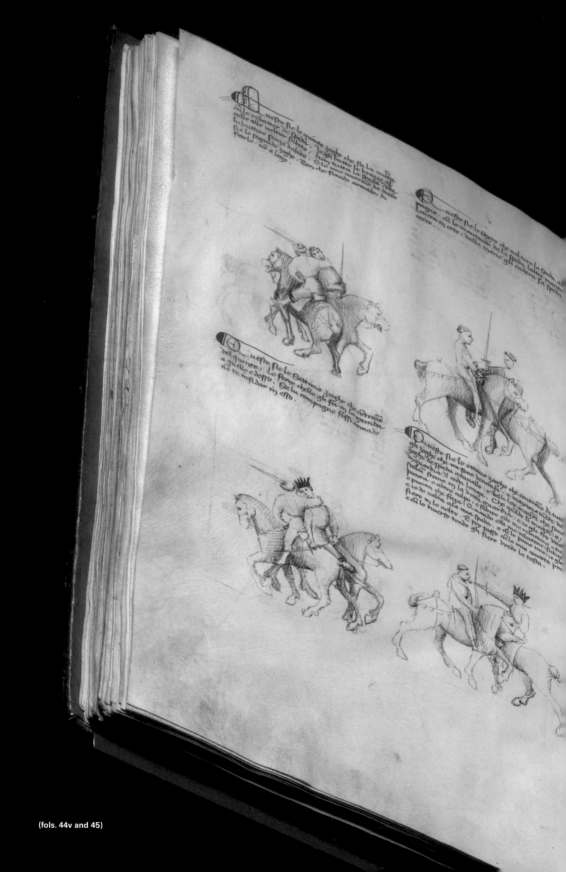

(fols. 44v and 45)

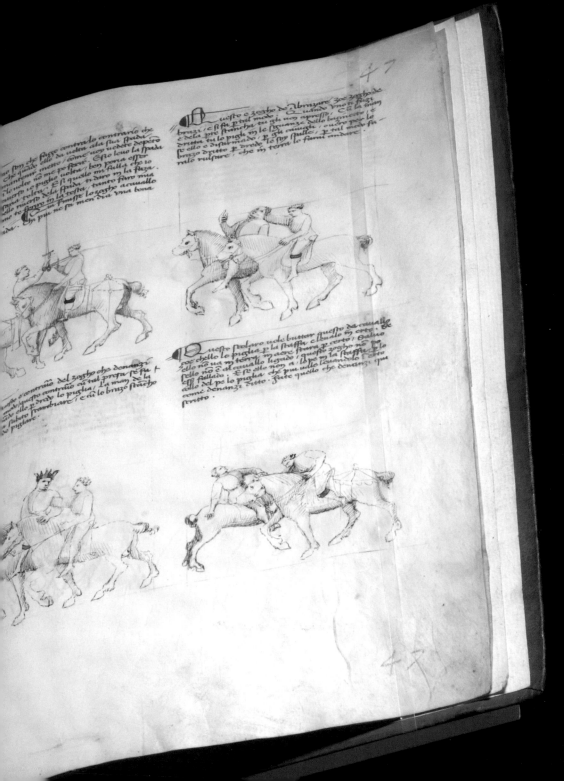

of his life and career comes from the prologues to his manuscripts. Since the Getty and Pisani-Dossi manuscripts of *The Flower of Battle* are dedicated to Niccolò III d'Este, Marquis of Ferrara, historians have tried to place Fiore in the latter's court. No record exists of him being on Niccolò's payroll, however, and since payments to household members were not recorded in the account books, Fiore would have been very close to the marquis or not employed by him at all. The last two students Fiore mentions in the prologue to the Getty manuscript were either Milanese or fought combats sanctioned and presided over by Gian Galeazzo Visconti, Duke of Milan. Gian Galeazzo was not named duke until 1395, therefore we can tentatively place Fiore's tutoring after this date. Fiore was also recorded in Pavia in 1399, which at that time was a Milanese possession and home to the Visconti library. We can thus speculate that the various copies of *The Flower of Battle* were intended as diplomatic presents from Gian Galeazzo Visconti to Niccolò d'Este. Significantly, both Gian Galeazzo and Niccolò were known as great patrons of writers and manuscript artisans. They gathered substantial libraries of scientific and practical arts, devotional works, and both ancient and contemporary literature, a critical development for the growing culture of the Renaissance, setting the stage for the creation of the modern research library.

Nonetheless, books on fighting or fencing were still rare at the time. Fiore mentions that none of his students, with the exception of Galeazzo da Mantova, a member of the noble Gonzaga family of Mantua who had married into the Visconti family, owned books on fencing. According to Fiore, Galeazzo held that written records were key to studying the martial arts—an opinion with

(*Combat with Sword*, fol. 35, detail)

which the Friulian fencing master agreed, saying that without books, one could hardly remember a quarter of the subject matter. Certainly, fencing books were not unknown in Milan. A near-contemporary text to Fiore's, called *Axe-Play* (*Le jeu de la hache*), the only fencing book written in French before the late sixteenth century, was penned by a Milanese master in the court of the duke of Burgundy. Although fencing books seemed to have originated among the clergy (that is, those who achieved upward mobility through education) in German-speaking lands, the enthusiasm for fencing books in medieval Italy seemed to be limited to the upper class—part of an overall strategy of literary patronage and martial accomplishment with which they distinguished themselves as separate from, and superior to, their counterparts in the rest of Europe.

The Getty Manuscript

Considering how detailed the illustrations are, the Getty's copy of *The Flower of Battle* is surprisingly small—only 28 by 20.5 centimeters (about 11 by 8 inches). Like most medieval manuscripts, it is written on parchment (carefully prepared skin from a sheep or goat). Before any writing or illustration took place, the blank pages were laid out in a geometrical grid that enabled a uniform presentation of text and drawings. The text is probably written in iron gall ink, made by extracting tannic acid from growths on oak trees called galls (which are caused by insect invasions), and mixing it with iron sulfate. The writing is in a neat, courtly hand in a popular style of writing called *bâtarde*, French for "bastard"—so-named because it is halfway between formal lettering and cursive. The drawings were done with a quill pen, probably made from a

15

goose feather. The gold highlights were made by first beating gold into extremely thin sheets. Bole, a fine, soft clay, was then applied to the areas of the design that would be gilded; the gold leaf, when pressed over the bole, would stick to this adhesive. The excess could then be brushed away, leaving the gold leaf only on the selected area.

Like all commissioned manuscripts from the Middle Ages, *The Flower of Battle* was carefully planned and designed. To construct a fencing book is not easy, and Fiore is quick to divulge that he knew how to "read, write, and draw." His mention of drawing ability is most interesting: Fiore clearly planned the illustrations to be an integral part of his work, and the style in which they are rendered helps to achieve his purposes. The pen-and-ink drawings in the Getty manuscript appear to have been created either by a single artist who used a variety of finishes or, more likely, by a group of artists working in a similar style. The manuscript's origin in early fifteenth-century northern Italy is made clear from both the Venetian dialect used in the text and from the cut of the clothing worn by the figures. Some scholars find a connection between the draftsmanship in the Getty manuscript and drawings based on works by Altichiero (ca. 1335–1393), the greatest northern Italian artist of the previous generation, as well as between the armor and costumes worn by his figures and those that appear in *The Flower of Battle*. Others think that Fiore himself was involved in the drawing process, though it is more likely that he supervised it or that the Getty manuscript was modeled after drawings from his hand. Though the finished manuscripts were almost certainly all the work of professional scribes and artists—the "printing presses" of the day—they probably worked from Fiore's original. Certainly, the organization of the text, with figures noted as "masters," "students," and "counter-masters" to explain techniques and counter-techniques, seems to be Fiore's own device.

Though we have no portrait of Fiore, we can imagine him in the stern visage of the Master of the Seven Swords. (*Aiming Points on the Body*, fol. 32, detail)

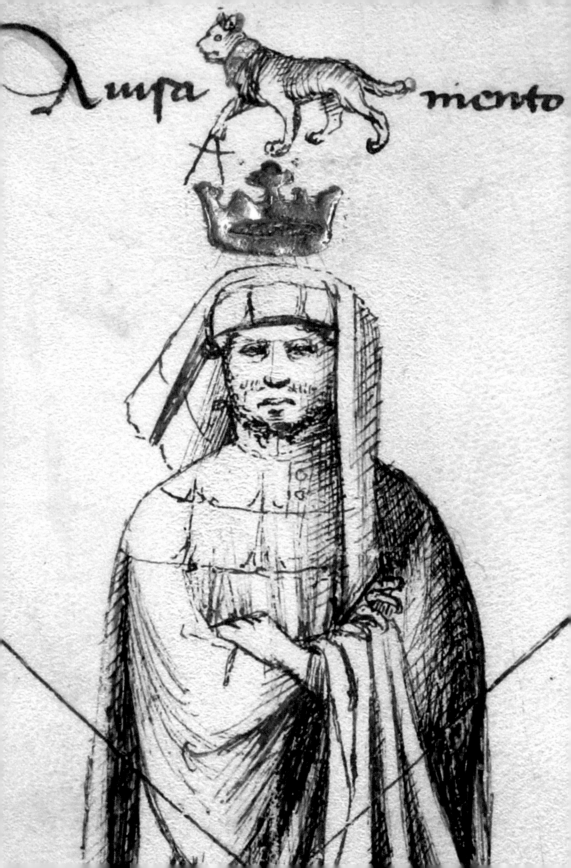

Anpa miento

The quality of the art also helps to convey Fiore's intent. The figures are delineated by expert hatching (shading) that lends them a convincing sculptural quality and spontaneity in their movements. In the equestrian section, figures sit firmly on horseback while grappling with an opponent, an effect that adds to the dynamism of the image and shows just how important a "good seat" is to mounted combat. Furthermore, the artist's precision in detailing hands and feet and alternation of light and dark areas not only gives us a sense of his mastery of the craft of draftsmanship but also shows how to find the position of maximum mechanical advantage over an adversary. In the same way, the illusion of depth both contributes to the overall sense of naturalism and shows the placement of limbs when executing the various techniques.

Structure and Use of Fiore's *Flower of Battle*
Martial arts, like any other human endeavor, do not exist in a social or cultural vacuum. As noted earlier, the arenas of war, duel, tournament, vendetta, and assassination overlapped considerably. For instance, the line between judicial duels, which were usually mortal, and tournaments, which were not intended to be fatal, was often blurred by bad blood. Similar fights were a popular sport among the knightly class both in times of war and in times of peace: during the Hundred Years' War French and English knights, though deadly enemies on the battlefield, would fight dangerous but ostensibly nonlethal challenges during truces. Likewise, an assassin's knife could bring a quick end to either a war or a family feud. In a sense, all violence was political—only the venue and the expectation of rules (or lack thereof) changed. Fiore, as a professional master-at-arms, knew that he had to prepare his students for any eventuality.

Nonetheless, it must be understood that *Fechtbücher* are not how-to manuals. Fiore does not address such basic subjects as how to parry, feint, or strike—subjects that any modern fencing mas-

ter would recognize as fundamental to teaching someone how to fence. Nor does he attempt to explain an overall theory of fencing. Rather, his work, like other medieval fencing books, was originally intended as a memorial, a reminder of teachings that would have been transmitted in person to select individuals. Fiore's idea of sharing knowledge was very different from today's digital democracy: he writes that he always taught in secret, with only a close friend or relative of the student allowed to watch—and only after being sworn to secrecy. He furthermore adds that he fought no less than five duels with jealous masters with whom he refused to share his secrets. This tidbit explains the cryptic nature of the Pisani-Dossi and Paris manuscripts, which do not contain explicit instructions but only caption the illustrations with taunting verses that have been described as a medieval version of "trash talk."

The Getty and Morgan manuscripts, however, include in-depth instructions on how to perform the various techniques. Why is this so? We can speculate that Fiore first sent one of the more abbreviated manuscripts of *The Flower of Battle* to Niccolò, who then requested a more complete work—one that could provide more detailed instructions to the reader, in keeping with the new culture of the book that was taking shape in Italian courts, and which manifested itself in the Visconti and d'Este libraries. The result was the Getty manuscript. Thus, while the Getty work is still not a how-to book—it presupposes that one already knew how to fence—it is a huge step toward that important Renaissance genre, the treatise on practical arts. Fiore's case may thus be that of an author whose patrons were perhaps more eager to take advantage of the literary culture of the Renaissance and the new ideal of sharing information than was the author himself. Fiore ultimately went along with this plan, for, as he remarks, he had an ulterior motive in writing: he wished to be remembered after his death, that is, to set down his work for posterity.

Fiore's Legacy

If posterity was Fiore's goal, then he succeeded. For a fencing master who played his cards close to his chest for most of his life, he has enjoyed considerable posthumous popularity. Codex 5278 in the National Library of Austria, dating from 1428, contains a number of images derived from *The Flower of Battle* (though no text). Derivative illustrations are also found in a notebook from the early sixteenth century, now in the university library of Erlangen, Germany, belonging to the general Ludwig von Eyb. Most interestingly, Fiore's work seems to have directly inspired the Pisan physician Filippo Vadi, who composed his *Fechtbuch* in the 1480s and dedicated it to Guidobaldo da Montefeltro, son of Federico da Montefeltro, lord of Urbino and a famous *condottiero* and patron of the arts. Vadi's work mirrors Fiore's closely, including its organizational principles and symbolism.

With the rise of the long, elegant rapier in the mid- to late sixteenth century, the longsword discussed by Fiore and Vadi fell out of favor among the upper classes. Fashionable fencing now concentrated on thrusting weapons and eventually developed into the modern techniques of foil, épée, and sabre. The last treatise on an art related to Fiore's was Francesco Alfieri's work on the two-handed sword from 1653. Contemporary with this development, print culture transformed the genre of the fencing book: rather than memorials intended to reflect instruction given in person, literary-inclined masters now penned treatises intended to theorize the art of fencing and explain their personal methods of using the sword. Works such as Fiore's were reduced to mere curiosities.

It was scholars and swordsmen in the late nineteenth century who first rediscovered medieval swordplay. Fencing had become an arena of nationalistic competition as a newly unified Italy, eager to take its place in the world, challenged France for prestige and supremacy. This rivalry was played out in a well-publicized series of matches and duels in the 1870s and 1880s; the modern

Olympic games, founded in 1896, only intensified this competition. Interest in each country's martial heritage was sparked anew, and, at least in terms of written records, Italy could claim a clear victory over France. The Italian historian Francesco Novati published a facsimile of the Pisani-Dossi manuscript in 1902, which was followed by Luigi Zanutto's somewhat fanciful biography of Fiore's life and times.

Interest in the manuscripts of Fiore dei Liberi, however, has never been higher than it is today, as modern practitioners of HEMA (Historical European Martial Arts) seek to revive the ancient fighting systems recorded in the *Fechtbücher*. Dozens of study groups, fencing schools, and amateur and professional scholars all around the world have once again made Fiore their teacher. Thanks to their energy and enthusiasm, we are experiencing a renaissance of the knightly arts of combat—albeit in a different and more peaceful context than they were originally intended.

This book is not meant as an exhaustive guide to the martial system of Fiore dei Liberi, nor as a full, scholarly exploration of his work and its meaning within its historical context. Rather, it is intended to serve as a visual tour of the Getty manuscript, an introduction to its significance both as a work of art and as a text, and to provide some historical background on the martial arts of Renaissance Italy. For those new to the study of medieval martial arts, it is a rare vision into the training of the medieval knight and its cultural context; for those enthusiasts already immersed in Fiore, it is a close-up look at the art and artistry of the Getty manuscript. This journey through *The Flower of Battle* provides a tantalizing glimpse not only of beautiful Renaissance manuscript illumination but also of a sophisticated martial art.

Wrestling

"I think that it is very important to know how to wrestle, for it is a great help in using all sorts of weapons on foot," Baldassare Castiglione wrote in his famous Renaissance manual of manners, *The Book of the Courtier*. Niccolò d'Este apparently thought along the same lines, for Fiore states in his prologue to the Getty manuscript that he began his book as the Marquis d'Este instructed him—with *abrazare* (wrestling), as Fiore calls it—literally "to embrace" in Italian. These skills provide a good basis for learning Fiore's martial art, since the same movements and principles for unarmed combat also apply to fighting with weapons.

 Abrazare is quite different from the modern sport of wrestling, being more similar to jujitsu. To be good at it, Fiore explains, requires not only strength and speed but also knowledge of wrestling holds, how to break or dislocate an opponent's arms and legs, joint locks (techniques that use leverage and body mechanics to immobilize and/or damage an opponent's limbs), where to punch or kick the adversary, and takedowns. Many of the techniques, such as breaking the adversary's nose or ripping off his ear, are definitely intended for self-defense in a life-and-death situation. Unlike modern mixed martial arts, however, Fiore does not deal with ground fighting. Not only did Italians consider wrestling on the ground undignified, but in a combative situation where one enemy could stab you while you were trying to grapple with another foe, it was dangerous to follow him to the ground. Fiore's strategy is therefore to put the opponent down quickly—preferably in such a way that he is not able to get up again.

22

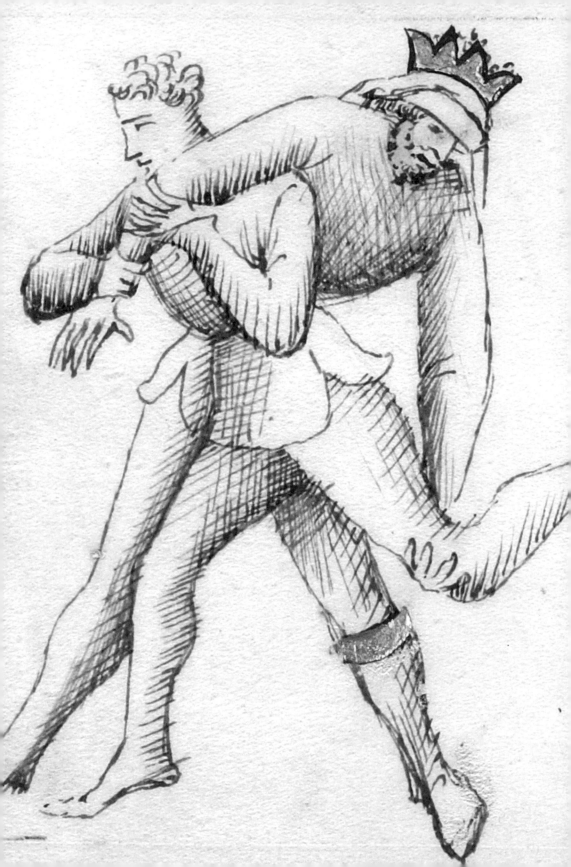

Io son posta longa e achosi te aspetto. E in la presa che tu mi voray fare. Lo mio brazo dritto che sta inmerto. Sotto lo tuo stancho lo mettero per certo. E intrero in lo primo zogho de abrazare. E cu tal, presa in tru ti faro andare. E si aquella presa mi uenisse a manchare. In le altre prese che seguen vigniro intrare.

In dente di zenghiar contra ti io vegno. Di romper la tua presa certo mi tegno. E di questa istro, e in posta di ferro intrero. E p metter te in terra faro aparechiado. E si aquello chio ditto mi falla p tua defesa. per altro modo cerchero di farte offesa. Coe cu rotute ligadure e dislogadure. In quello modo che sono depente le figure.

In porta di ferro io ti aspetto senza mossa. per guadagnar le prese a tutta mia possa. Lo zogho de abrazare a quella e mia arte. E di lanza, azza, spada, e daga o grande parte. Porta di ferro son di malitie piena. Chi contra me fu sempre gli do briga e pena. E ati che contra mi voi le prese guadagnare. Cu le forte prese io ti faro i terra andare.

Posta frontale son p guadagniar le prese. E in questa posta vegno, tu me farai offese. Ma se mi mouero di questa guardia. E ai tzegno ti mouero di porta di ferro, pego ti faro stare che staresti i inferno. De ligadure e rotture ti faro bon merchato. E tosto si vederi chi avera guadagnato. E le prese guadagnero se no saro sm emorato.

Each section begins with masters, who are marked with crowns, showing *guardie* (guards or ready stances) from where a fencing or wrestling action is begun, and *poste* (positions), which can describe both guards and the positions through which a fighter flows when performing combative techniques. Fiore tells us the two terms are interchangeable, but he seems to use the more common term *guardia* to connote static positions, whereas he prefers his own, more versatile term *posta* to convey a fluid sense of linked movements. On this page, the positions are, from top to bottom and left to right: "long position," "boar's tooth," "iron gate," and "frontal position." (fol. 6)

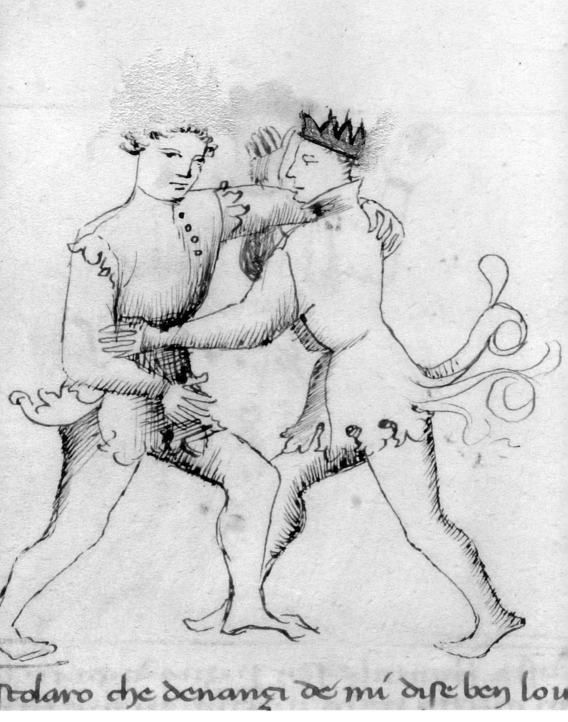

Fiore begins each series of defensive and offensive actions with a crowned master showing a defense to a particular type of attack. In this illustration, the first wrestling master breaks his opponent's hold. (fol. 6v, detail)

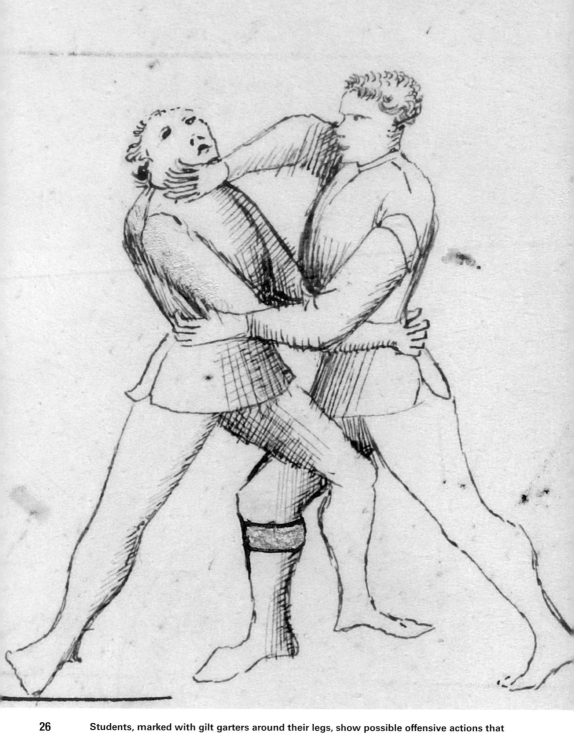

26 Students, marked with gilt garters around their legs, show possible offensive actions that can follow the defense. Here, a student of the first master steps behind the adversary while placing a hand across his throat or face to throw him to the ground. (fol. 7, detail)

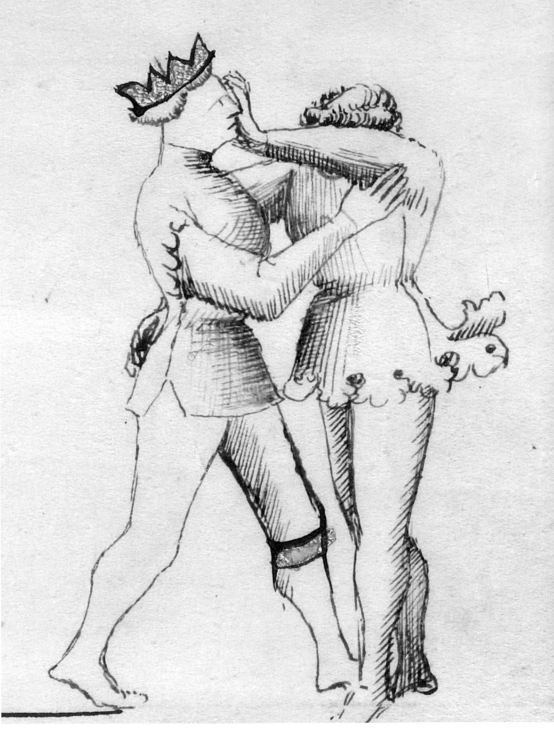

In the next technique in the sequence, a counter-master, marked with both a crown and
a garter, counters the student's action, pushing his hand away and turning him around.
Because Fiore previously showed how to do the technique right-handed but here shows how
to perform the counter against a left-handed attack, it is important to pay careful attention
to both illustrations. (fol. 7, detail)

In this illustration, the defender ducks under the foe's extended arm and prepares to pick him up by holding the arm across his shoulders while grasping his opponent's thigh. The technique is similar to the judo *kata guruma* (shoulder wheel). Fiore says that there is no good counter to this play; the hasty manner in which the artist drew the extended arm indicates something of the speed with which the technique must be executed, while the energy of the lines of the left hand of the figure being thrown shows just how much trouble he finds himself in.

(fol. 7, detail)

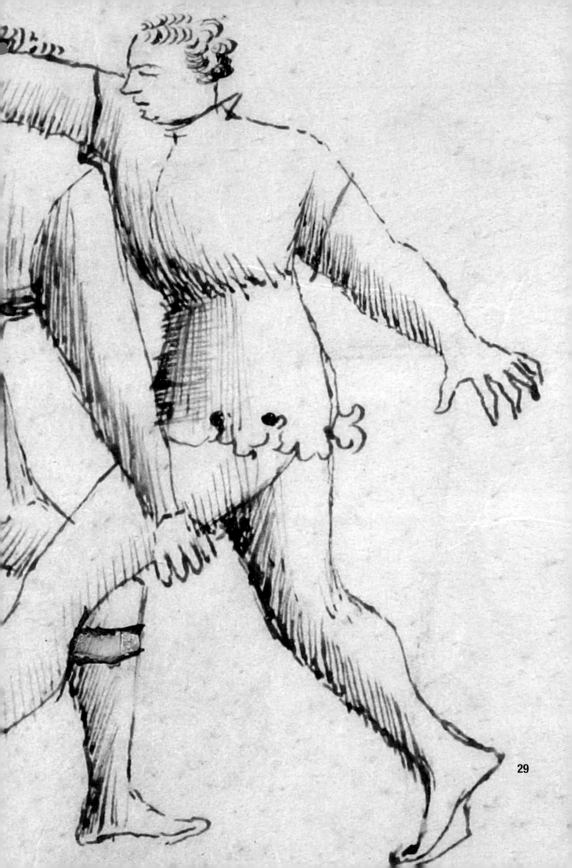

29

Self-Defense

Learning practical self-defense was as necessary to the medieval Italian nobility as learning how to comport oneself in a tournament. Assassination was considered a viable diplomatic tool: for instance, in 1409, Niccolò d'Este had the mercenary captain Ottobuono Terzi stabbed to death at a peace conference by Niccolò's own *condottiero*, Muzio Attendolo Sforza. Sforza was in the habit of riding half-trained horses to show off his equestrian skills, so when the parties met for a tense meeting in the middle of a field, Terzi, distracted by more pressing matters, thought nothing of it when Sforza's horse shied and carried him away from the negotiations—which, in turn, allowed Sforza, who was actually in perfect control of his mount, to ride up and deliver a fatal dagger thrust.

Vendetta was another deadly reality in Fiore's world. Among all orders of society, the code of honor dictated an eye for an eye and a tooth for a tooth. As a magistrate in the service of the city of Udine in the aftermath of the Friulian civil war, Fiore was commissioned to bring order to a lawless environment. It was therefore important for a man-at-arms not only to know how to meet an adversary on equal footing but also how to defend himself against a sudden attack.

(Combat with Dagger, fol. 12v, detail)

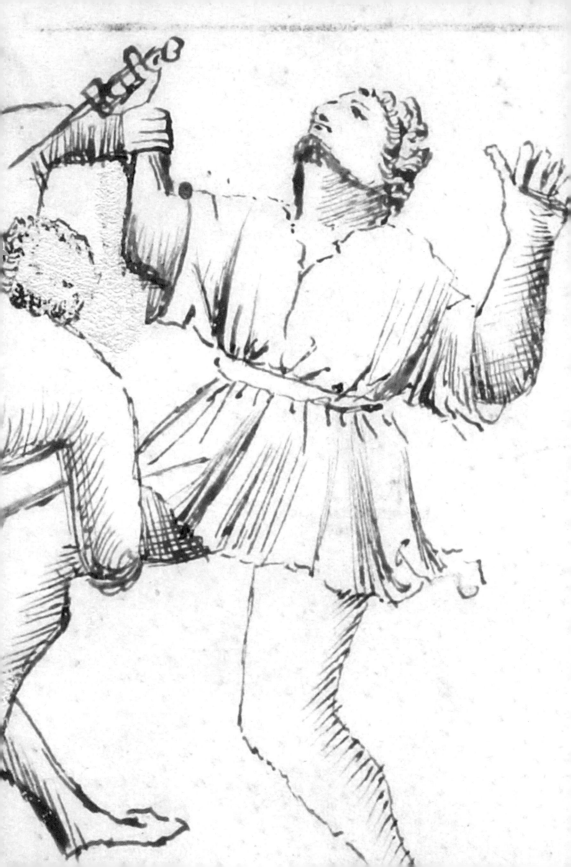

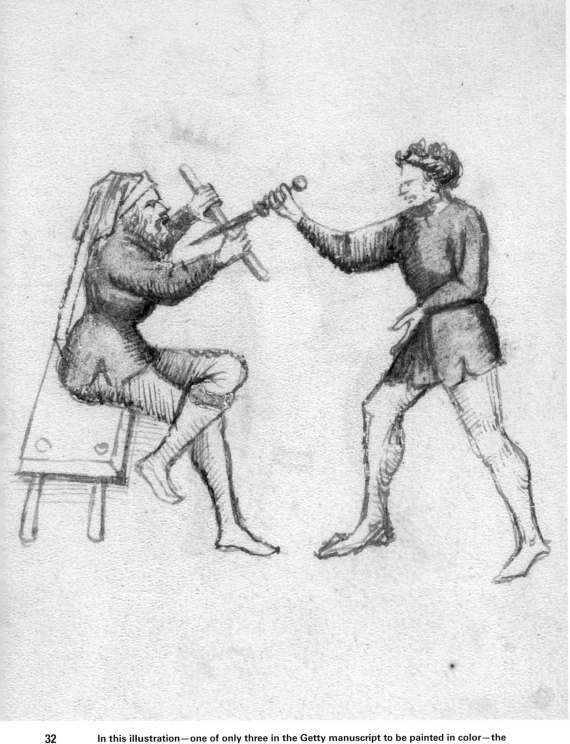

32 In this illustration—one of only three in the Getty manuscript to be painted in color—the man seated on the bench defends himself with a *bastoncello* (short baton), a traditional symbol of authority. This scene can easily be imagined as an assassination attempt by a disgruntled defender called into court or a military commander faced with an adversary's attempt to end a war quickly and decisively. (fol. 8v, detail)

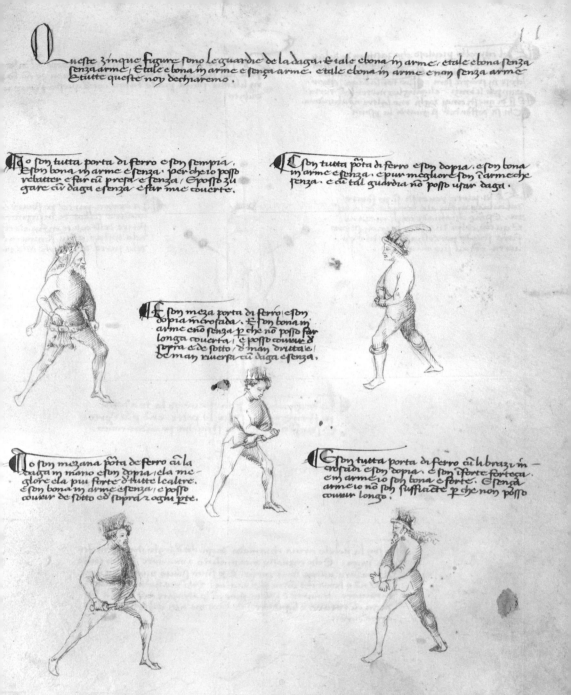

As he did with the wrestling masters (see p. 24), Fiore here presents the dagger positions, noting in the text which are best for use in armor or when wearing street clothes. (fol. 9)

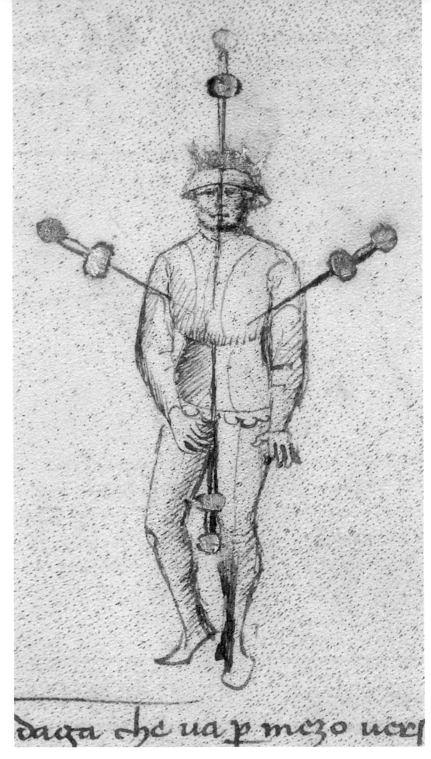

daga che ua p mezo uer[

34 This diagram shows the targets for the dagger and acts as an index of the various coun-
ters. The text advises that when faced with a knife or dagger, it is best to quickly destroy
the enemy's ability to attack and put him on the ground. (fol. 9v, detail)

Ser che io porto daga in mia mane dritta, io la
...to p mia arte chella o ben meritada, che zaschun
...me tirava di daga, io gliela toro di mano. E cu quella
...avero ben ferine, po che lo pro el contra del tutto
finire.

Per gli brazzi rotti ch'io porto, io uaglio dir mia
arte, che questa senza uoler mentire, che assay no rotti e
displaçadi in mia uita, e chi contra mia arte se mettera
uoler fare, tal arte sempre io son p uoler usare.

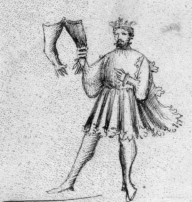

...o son magro de auere canche di serare zoe gli
...zi achi contra mi uol fare, io lo mettero l'grand
...ge e stente p modo che le ligadoure e rotture sono
...ente. E zo porto le chiaue p insegna, che tal
...e ben me degna.

Me domandauoy p che io tegno questo homo sotto
gli miei piedi, p che anzilara no posti a tale partito
p larte dello abraçare. E uittoria io porto la pal-
ma in la man destra po che dello abraçare z a mai
no so resta.

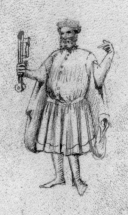

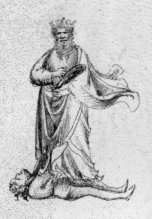

These figures hold symbols that visually depict what Fiore explained in the previous
folio (opposite): daggers must be taken away (upper left), arms must be broken (upper
right), and the key is to lock the attacker into a wrestling hold (lower left) and then
throw him to the ground (lower right). (fol. 10)

35

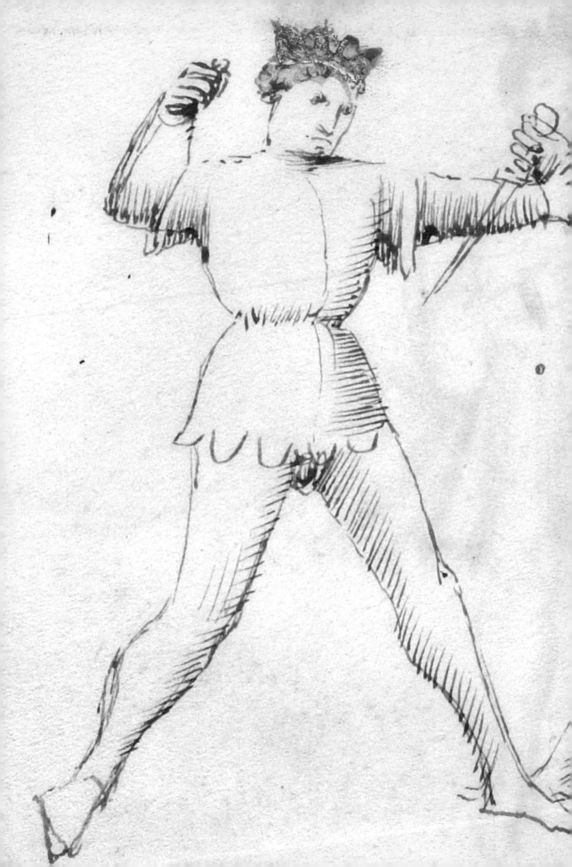

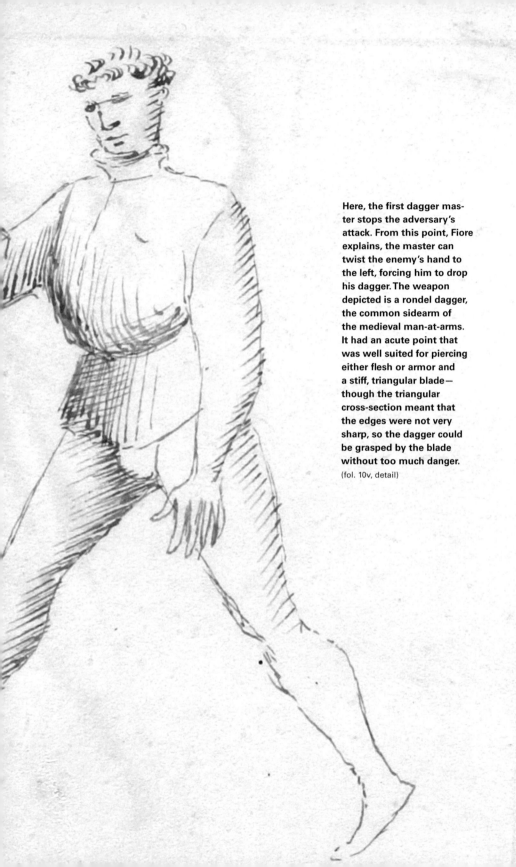

Here, the first dagger master stops the adversary's attack. From this point, Fiore explains, the master can twist the enemy's hand to the left, forcing him to drop his dagger. The weapon depicted is a rondel dagger, the common sidearm of the medieval man-at-arms. It had an acute point that was well suited for piercing either flesh or armor and a stiff, triangular blade— though the triangular cross-section meant that the edges were not very sharp, so the dagger could be grasped by the blade without too much danger. (fol. 10v, detail)

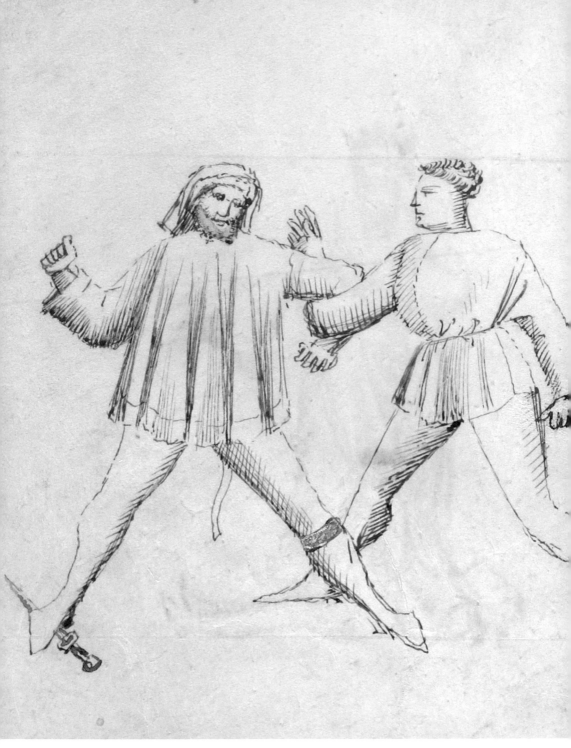

38 **From the first master's defense, the student can place the foe in an arm lock. The disarmed dagger is shown under the student's foot.** (fol. 10v, detail)

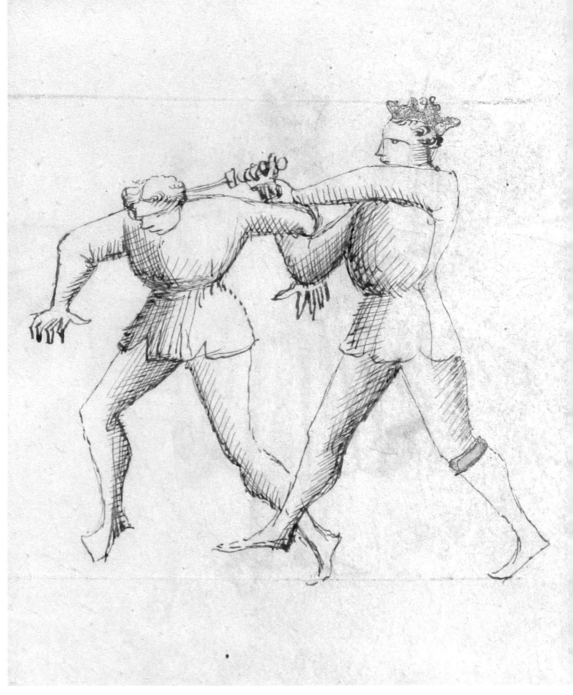

The attacker, however, can defeat the defense by grasping his own arm and using the increased leverage to place the defender in a joint lock. (fol. 10v, detail)

In bona chouerta p̃ tor ti la daga di mano. Anchora p̃ tal presa te porta ben ligare. E se io metesse la mia man dritta sotto. lo tuo dritto zinochio. In terra te faria andare. po che questa arte ben la so lo fare.

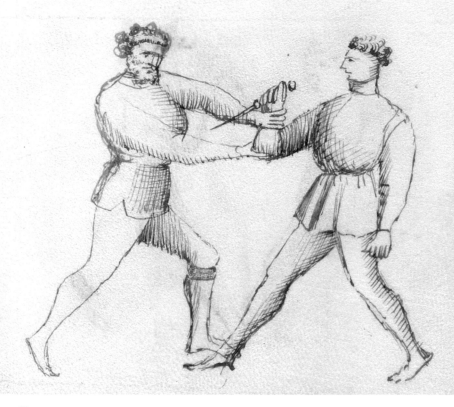

40 This illustration shows how the student turns the attacker's elbow to put him in a joint lock—which the attacker can counter, just as before, by grasping his own dagger for increased leverage, as shown on the opposite page. (fol. 11, details)

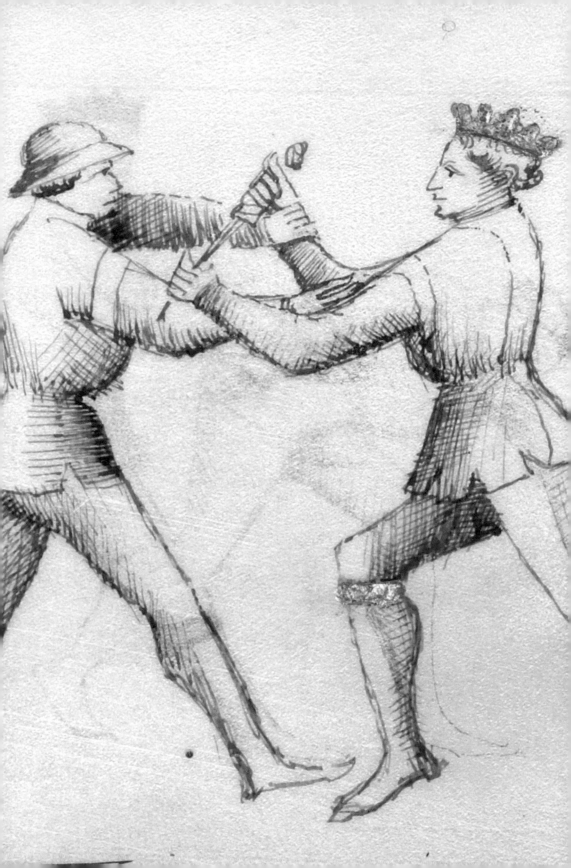

Sword

The sword was historically the knight's sidearm of choice, but by the late four-teenth century, its form had undergone significant changes. Swords had become long and pointed in order to pierce armor and could be used in one hand on horse-back or in two hands on foot. This sort of weapon, popular throughout Europe, is known in English as the longsword. Even after it fell out of fashion with the upper classes in the sixteenth century, fencing with the longsword remained a popular sport up until the French Revolution, and remnants of this skill survive today in modern European stick-fighting arts such as the French *bâton* and Portuguese *jogo do pau*.

Most of the techniques in Fiore's sword repertoire involve some sort of wres-tling, which seems counterintuitive considering that when fighting with a three-to-four-foot-long piece of sharp metal, staying as far away as possible would seem to make the most sense. One possible explanation is that Fiore probably would have personally taught parries, ripostes, and other long-distance techniques that are difficult to describe in words; the illustrations and text only served to remind the student of his principles. Another is that the emphasis on close combat high-lights Fiore's priorities: in a serious fight, as opposed to sporting play, a com-batant should always control the adversary's weapon or body, making sure that there is absolutely no way he can strike back. Unlike in a movie, a real sword fight is usually quick, decisive—and deadly.

(*Combat with Sword*, fol. 25v, detail)

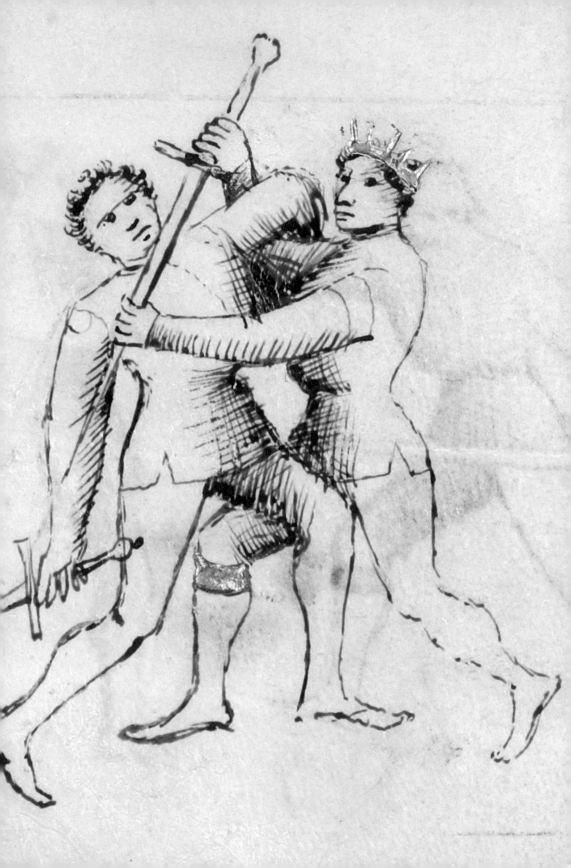

This mnemonic diagram shows the seven directions in which a blow may travel, surrounded by symbols of the four virtues that Fiore believed to be most critical for the skilled swordsman. Above the figure's head, a lynx with a compass judges distance. On the left, swiftness is embodied by a tiger holding an arrow. To the right, a lion with a heart stands for courage. Finally, at the bottom of the page, an elephant with a tower on its back represents strength, balance, and a strong stance. (fol. 32, detail)

Meglio d mi louo ceruiero nõ uede
Mercada. Gaquello mette semp a sesto
e amisura.

. Auisa mento .

Eu de mi t.
core ardito
fazo azasth

. Ardiment .

 te son e
uizmochio

Vn castello porto p chargo
ne peo uango .

Forteza .

oy femo doi guardie vna fi facta che laltra, e vna e contraria delalem. E zafchuna altra guardia in larte vna fimile delaltra fie contrario faluo le guardie che ftano in puncta zoe pofta lunga e breue e meza porta di ferro che puncta p puncta la piu lunga fa offefa inanci. E zo che io far vna po far laltra. E zafchuna guardia po fare uolta ftabile e meza uolta. La uolta ftabile fie che ftando fermo po zugar denanci e di dredo de una parte. e meza uolta fie e quado uno fa vn paffo o inanzi o indredo. e choffi po zugare de laltra parte de nanzi e di dredo. tutta uolta fie qn uno ua intorno vno pe cu laltro pe, l uno ftaga fermo e laltro lo circundi. E pzo digo che la guida fi ha tre mouenti zoe uolta ftabile, mezauolta, e tutta uolta. E quefte guardie fono chia mate l una e laltra pofta di donna. Anchora fono uy, cofe in larte zoe paffare, tornare, acreffere, e diftreffe.

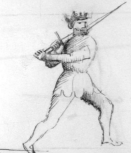

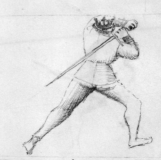

oy femo fey guardie e vna no e fimile delaltra. E io fon la pimera che digo mia ragione. De lanzar mia fpada quefta e mia condicione. Le altre guardie che d mi fono dredo, diranno le lor uirtude co me io credo

fon bona guardia in arme e fenza, e contra laza e fpada zitada fora di mano, che io le fo rebattere e fchiuarle. po me tegno certo che io me pon far male.

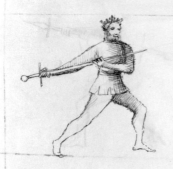

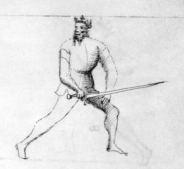

46 Fiore begins his sword section by explaining his footwork, showing how to wield the
weapon in front or to the side, or turn to meet a threat from behind. The two figures in
the lower register are, respectively, preparing to throw a sword and to deflect a flung
sword. (fol. 22)

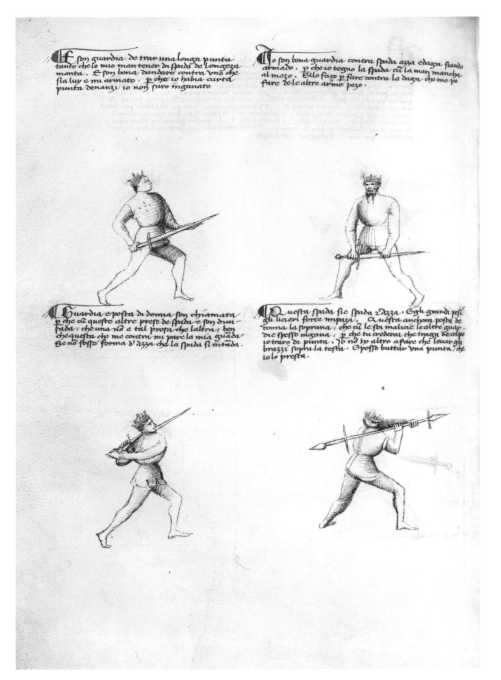

This page shows positions for use while wearing armor. On the lower right, the unusual-looking weapon serves to show that in a combat situation, not just the blade but all parts of the longsword could be utilized as a weapon: a combatant could use the quillons (cross-guard) as an axe, smash with the pommel, or use the whole blade as a lever in grappling. (fol. 22v)

Noy femo fendenti ꝛ ĩ l'arte facemo queftione
de fender gli denti ꞓ ꝛuar alo ʒinochio cũ ꝛafone·
Ꞓ ogni guardia che fi fa terrena / Duna guardia
ꝑ laltra andamo fenʒa pena· Ꞓ rompemo le guade
cũ inʒegno· Ꞓ cũ colpi faʒemo de fangue fegno·Noi
fendenti dello ferui no auemo tardo / Ꞓ tornamo ĩ
guardia de ꝑgo ĩ ꝑgo·

Ꞓ le colpi fottani femo noi / ꞓ comĩʒamo alo
ʒinochio / ꞓ andamo ꝑ meʒa la fronte· ꝑ lo camino
che femo gli fendenti· Ꞓ ꝑ tal modo che noi motamo
ꝑ quello camino noy retornamo / Ouero che noi
remanemo ĩ pofta longa·

Colpi fendenti·

Colpi Sottani·

Colpi meʒani femo chiamadi ꝑ che noy anda
mo ꝑ meʒi gli colpi foprani ꞓ fottani· Ꞓ andamo cũ
lo dritto taglo dela ꝑte dritta· Ꞓ dela ꝑte riuerfa
andamo cũ lo falfo taglio· Ꞓ lo noftro camino ſte
dello ʒinochio ala tefta·

Noy femo le punte crudele ꞓ mortale· Ꞓ lo
noftro camino ſie ꝑ meʒo lo corpo comĩʒando alo
petenichio ĩ fin ala fronte· Ꞓ femo punte d·y·
rafone / ʒoe doy foprane vna duna ꝑte laltra de
laltra· Ꞓ doy de fotta fimile mente vna duna
ꝑte ꞓ laltra delaltra / Ꞓ vna de meʒo che effe de
meʒa porta de ferro o uero de pofta lunga ꞓ breue·

Colpi meʒani

Le punte

48 Here, Fiore names his *colpi* (blows): upper left, *fendenti* (descending); upper right and opposite, *sottani* (ascending); lower left, *mezzani* (horizontal) cuts; and lower right, *punte* (thrusts). Attacks and defenses are made by fluid transitions between stances and intermediary positions. (fol. 23)

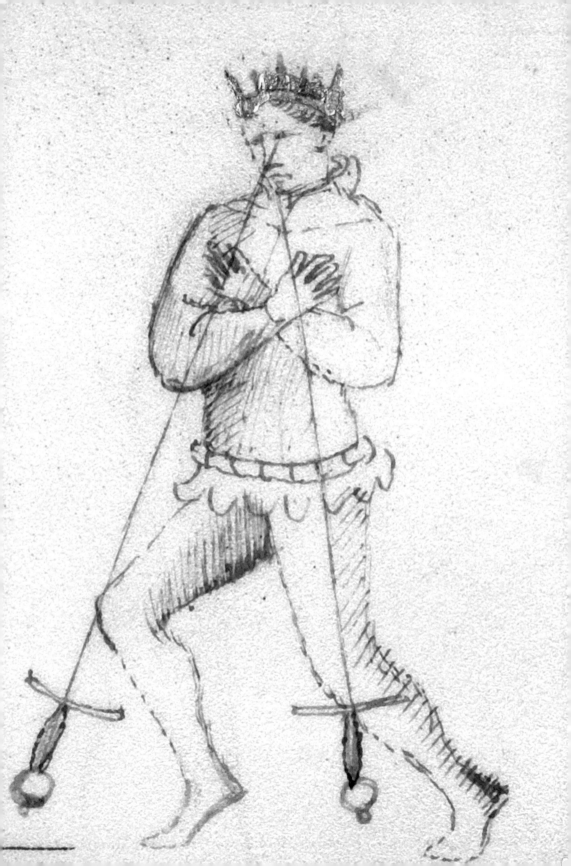

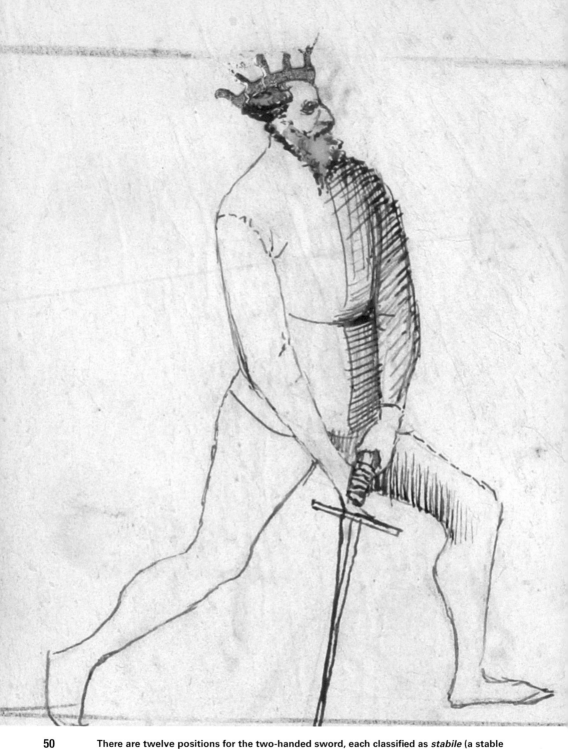

50 There are twelve positions for the two-handed sword, each classified as *stabile* (a stable
position, in which a combatant could await the adversary), *instabile* (transitional), or
pulsativa (ready to strike). Shown here is the *pulsativa* position "complete iron gate,"
from which the participant can strike out against the enemy or invite him to make his
own attack. However, this position cannot be held long. (fol. 23v, detail)

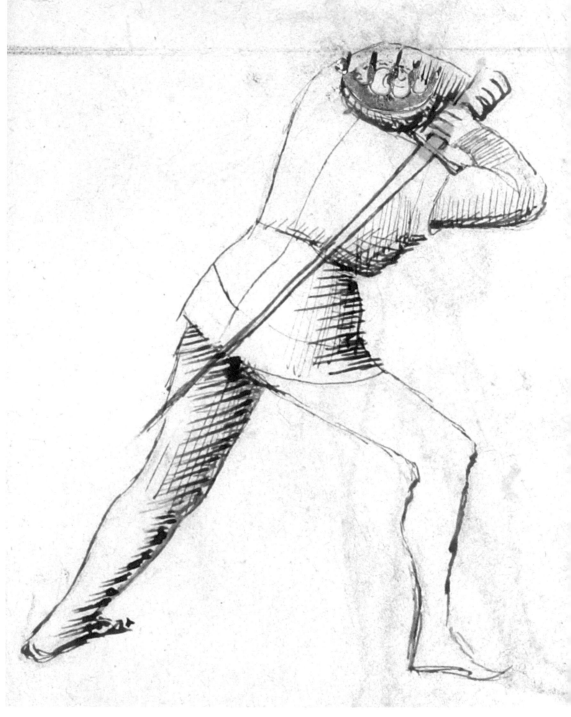

The *pulsativa* "woman's" *posta* holds the sword hidden behind the back, ready for a powerful strike or parry. (fol. 23v, detail)

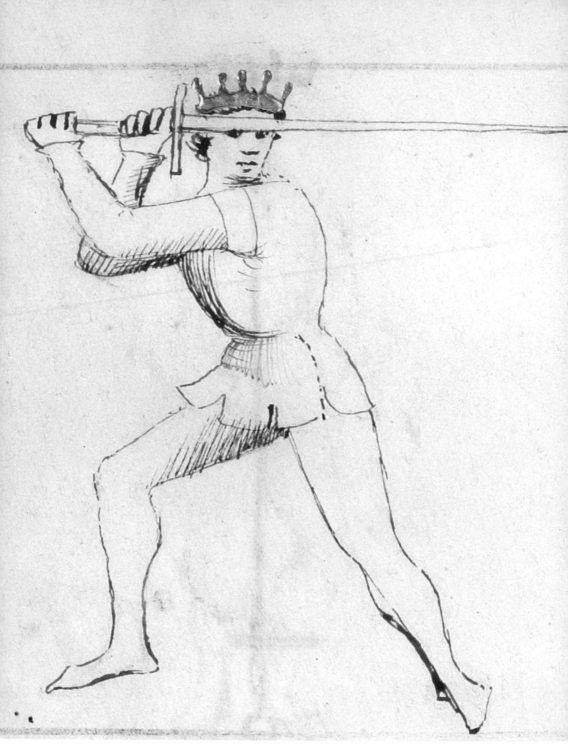

52 Similar to the woman's *posta*, the *instabile* "window" *posta* can be used for offense or defense. It can lead to a powerful cut or thrust, defend the body by merely dropping the point of the sword, or enable the fighter to make a counter-thrust while stepping off the line of the attack. (fol. 23v, detail)

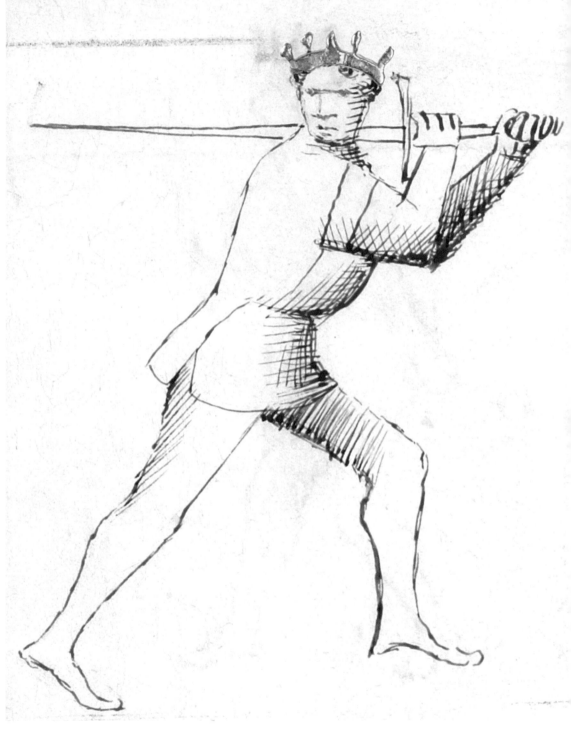

This is the woman's *posta* holding the longsword on the left side. The artist's careful rendering of anatomical detail shows how the combatant turns his hips to deliver a more powerful blow: the first strike should make sure the foe is incapacitated or killed.
(fol. 23v, detail)

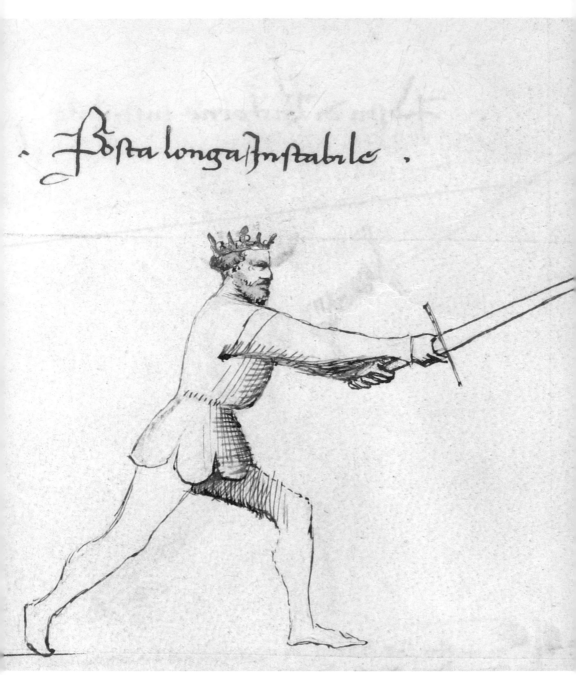

Posta longa Instabile

54 The long position (above) is *instabile*; one should not stay there for long. It is not only the end position after many strikes but also the position to use when feinting a thrust. The "middle iron gate" (opposite) is similar to the complete iron gate (see p. 50) but requires a longer blade. Like its cousin, this position makes it possible to both strike and defend but, because it is *stabile*, one can use it to await the foe. (fol. 24, detail)

Porta di ferro mezana / stabile

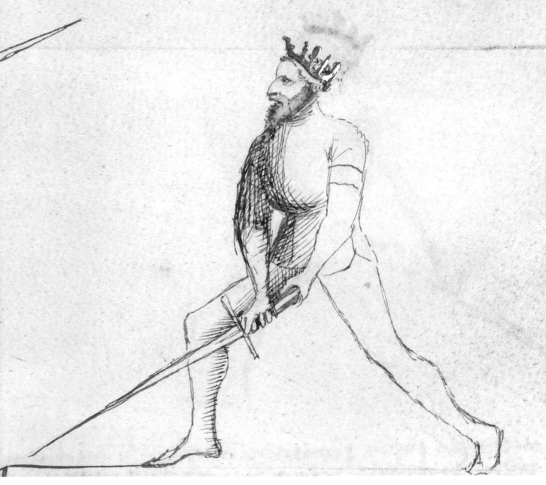

Posta breue stabile

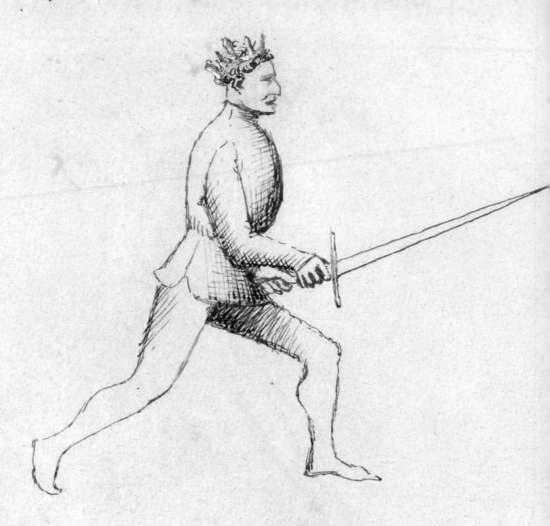

Above is the *stabile* "short position," which requires the use of a long blade and probes the adversary for a chance to make a thrust. To the right is the similarly *stabile* "boar's tooth," which strikes up from below. (fol. 24, details)

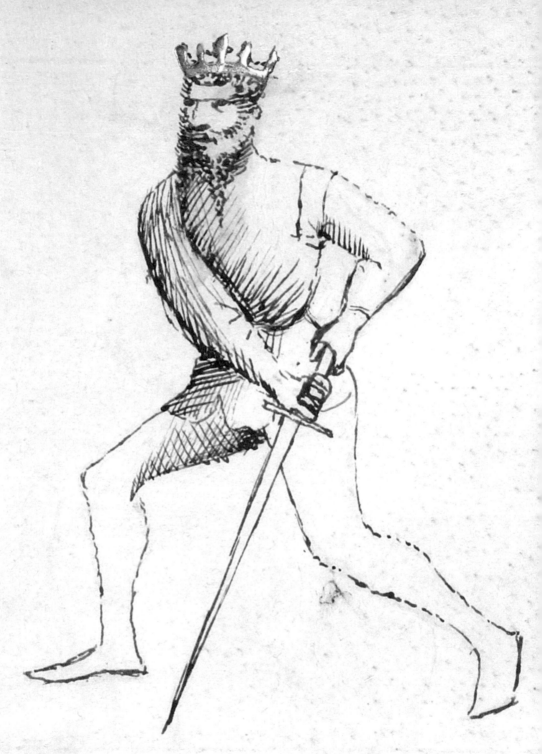

Questa sie posta di coda longa che desfesa in terra di dredo, ella po metter punta, e denanci po couerir e ferrire. E se ello passa manci e tra del fendente in lo zogo stretto entra senza fallimento che tal guardia e bona p aspettare, che de quella in le altre tosto po intrare.

Questa e posta di bicorno che sta cosi strada che sempre sta cu la punta p mezo de la strada. E quello che po fare posta longa, po fare questa. E similemente dico de posta di fenestra e di posta frontale.

. Posta di choda longa stabile .

. Posta di Bichorno instabile .

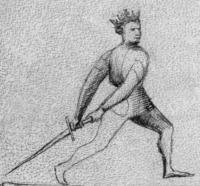

Questa sie posta frontale chiamada dalchun magiti posta di corona, che p morofar ella e bona, e p le punte elle anchora bona, che se la punta gle uen trutta erta, ella la morofa passando fuora di strada. E se la punta e trutta bassa, anchora passa fuor di strada rebattendo la punta a terra. Anchora po far altra mente, che in lo trar de la punta torin cu lo pe in dredo e uegna da fendente p la testa e p gli brazzi e uada in dente di cengiaro e subito butti una punta o doe cum acrester di pe e torin di fendente in quella pria guardia.

Questo sie dente di cengiaro lo mezano che sono doy denti di zengiaro l uno tutto l altro sie mezo, po e ditto mezo, p zo chello sta in mezo de la psona, ezo che po fare lo tutto dente, po fare lo mezo dente. E in modo che fieri lo zengiaro a trauersa p tal modo se fa cu la spada che sempre fieri cu la spada ala trauersa dela spada del compagno. E sempre butta punte e distroua lu e pagno, e semp guastagli le mane e tal uolta testa egli brazzi.

. Posta frontale ditta corona Instabile .

. Posta di dente zenchiaro mezana Stabile .

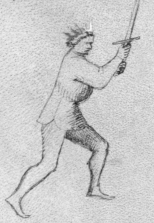

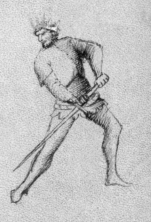

58 These four *poste* are, from top to bottom and left to right: the *stabile* "long tail"; the *instabile* "two-horned" *posta*, which acts much like the long position (see p. 54); the *instabile* "frontal position," a parry; and the *stabile* "middle boar's tooth," (detail opposite) which is like the "boar's tooth" (see p. 57) but in the centerline. Note the attention to detail with which the artist has distinguished these two boar's tooth postures. (fol. 24v)

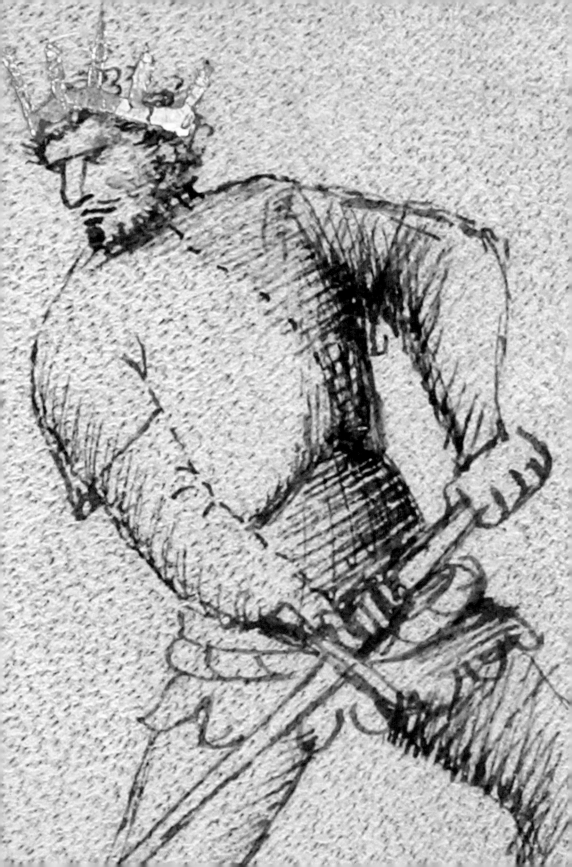

Quesin sono tre compagni cheuoleno alader questo magro che aspetta cu la spada a doy mane. Lo primo di questi tre uole lanzare la sua spada ontra lo magro. Lo segondo uole ferire lo detto magro o tagio o de punta. Lo terzo uole lanzare doy lanze chello a parechiad, come qui depento.

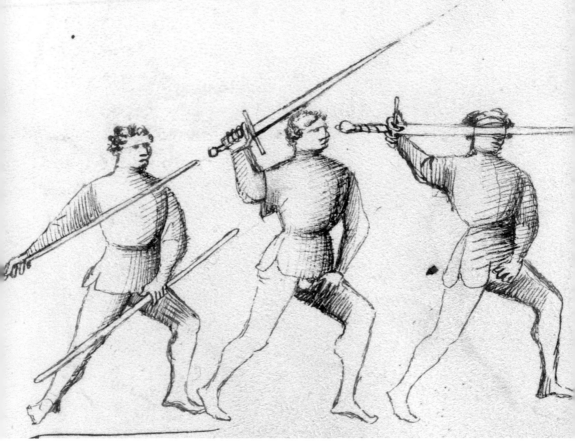

Fiore says that the sword can beat any weapon. Because of its versatility, any part can
be used to wound an opponent, and it can be employed at short and long range and
in wrestling. It is also the very image of the Christian cross, symbolizing the ability to
enforce justice and fight wrongdoing. Here, the master (on the far right) stands in boar's

o ſpetto queſti tre m tal poſta / zoe m dente di
zengiaro / em altre guardie poria ſpettare / zoe
m poſta de donna la ſeneſtra / mohora m poſta di
fmeſtra ſmeſtra / cu quello modo e deffeſa che ſan
m dente di zenghiaro . zal modo etal deffeſa le
dute guardie debiam fare . Senza paura io ſpe
tto vno a vno / cnõ poſſo fallire / ne taglio ne puta
ne arma manuale che mi ſia lanzada . lo pe drito
chio denanzi acreſto fora de ſtrada / e cu lo pe ſtan
cho paſſo ala trauerſa del arma che me mcontn
rebatendola m pte ruuerſa . e p queſto modo fazo
mia deffeſa . Fatta la couerta ſubito faro loffeſ

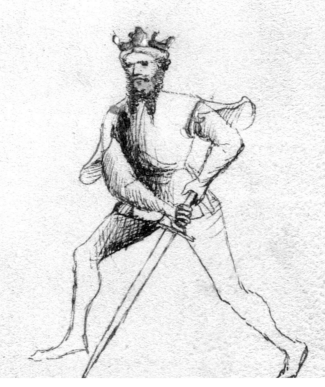

tooth and faces foes waiting to, from right to left, throw a sword, strike with the sword, and hurl two javelins. This is not meant to represent three-on-one combat, but rather to show that no matter how the opponent attacks, it can be countered with skill in swordsmanship. (fol. 31, detail)

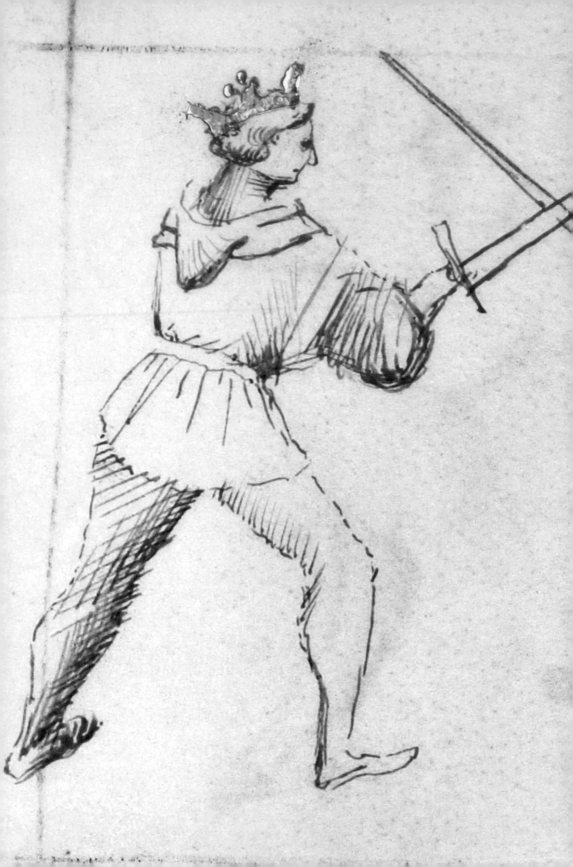

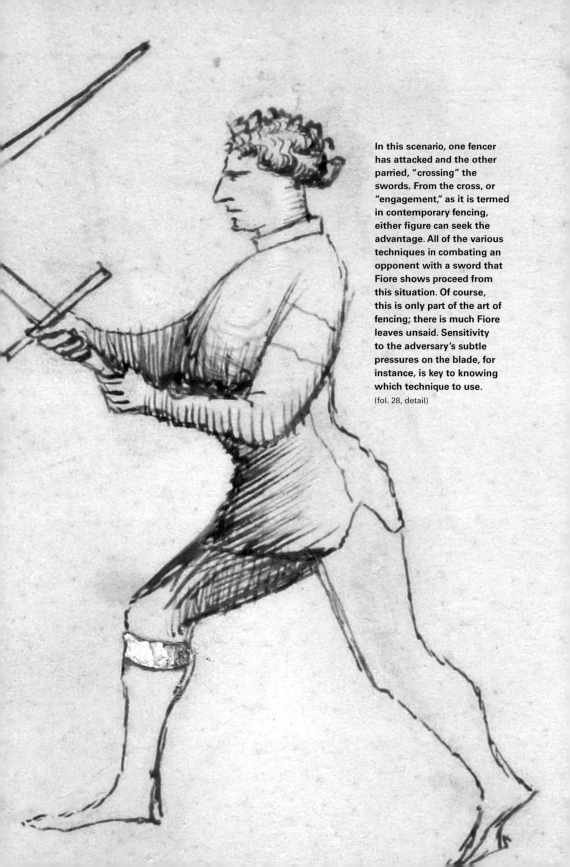

In this scenario, one fencer has attacked and the other parried, "crossing" the swords. From the cross, or "engagement," as it is termed in contemporary fencing, either figure can seek the advantage. All of the various techniques in combating an opponent with a sword that Fiore shows proceed from this situation. Of course, this is only part of the art of fencing; there is much Fiore leaves unsaid. Sensitivity to the adversary's subtle pressures on the blade, for instance, is key to knowing which technique to use.

(fol. 28, detail)

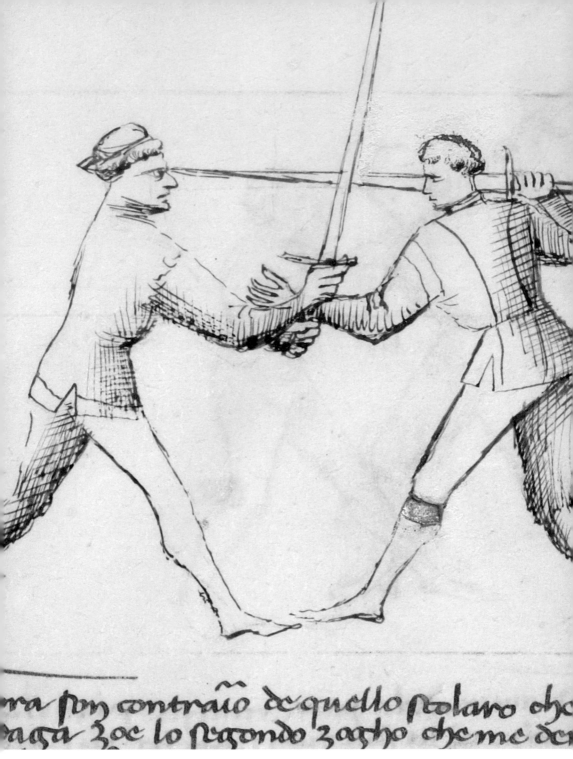

ra son contraio dequello scolaro che
aça zoe lo segondo zogho che me de

64 Just as with the dagger defense on pp. 38–39, the student has reached in to lock the attacker's arm. The attacker can use the same counter, grasping his own blade for increased leverage and putting the student in a wrestling hold, as shown opposite.

(fol. 29v, details)

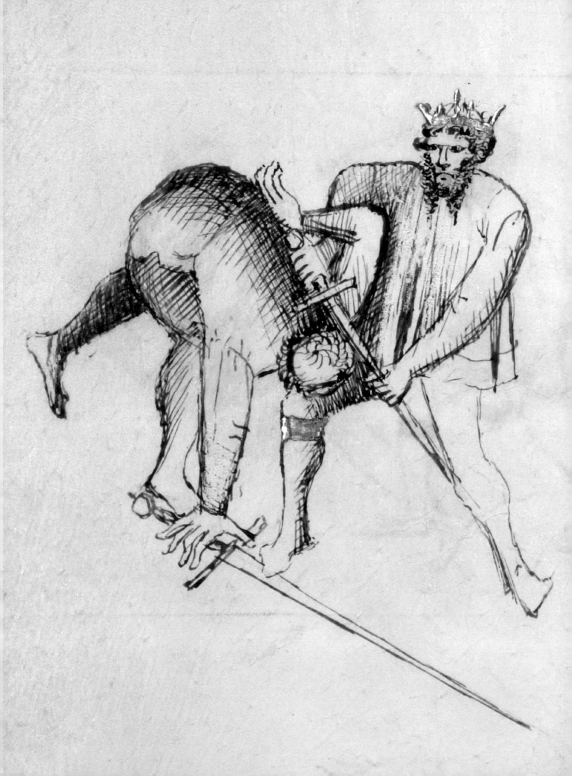

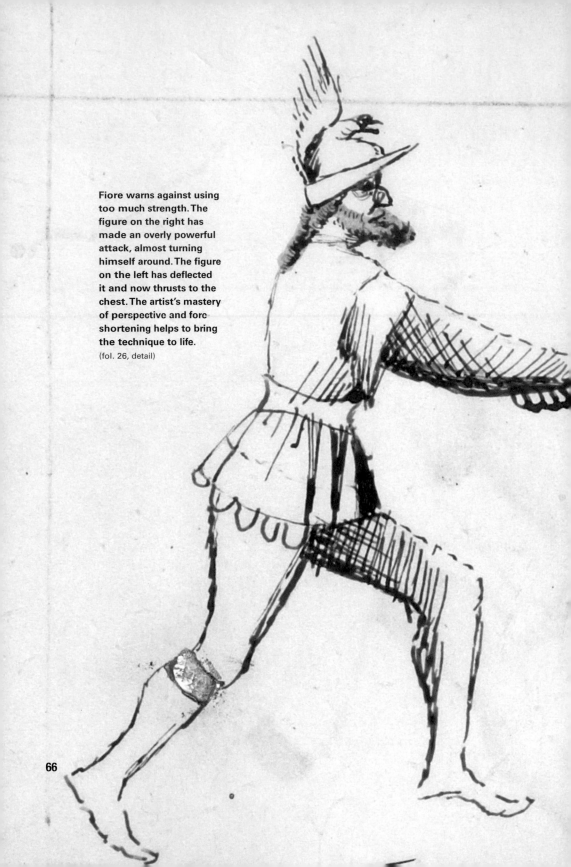

Fiore warns against using too much strength. The figure on the right has made an overly powerful attack, almost turning himself around. The figure on the left has deflected it and now thrusts to the chest. The artist's mastery of perspective and foreshortening helps to bring the technique to life.
(fol. 26, detail)

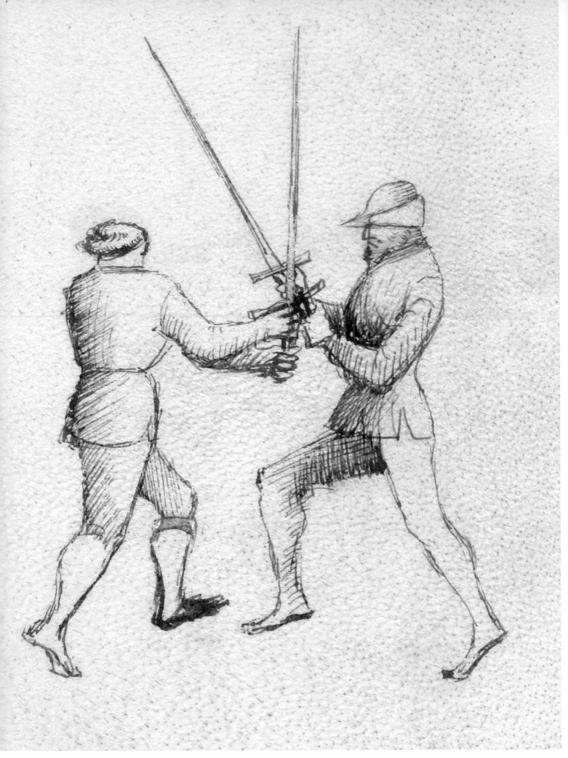

68 **Grappling can take place at short, medium, and long range. Here, the student will lift the adversary's hands with the hilt of the sword and pin his arms.** (fol. 28v, detail)

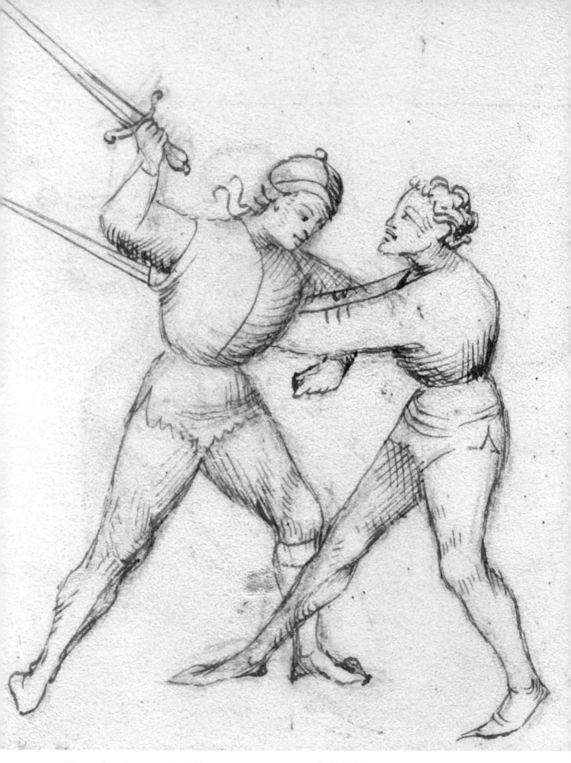

The student has completed his move. The adversary is held helpless and can be struck at leisure. (fol. 29, detail)

Fighting in Armor

A shirt made of mail, a flexible mesh of interlinked metal rings, was the medieval man-at-arms' primary protection. By the time Fiore was born, this form of armor had been supplemented by articulated plates of metal, which formed a protective shell that was almost impossible to penetrate. This development can be seen as the result of an arms race: as more effective weapons were developed, so, too, did defensive armament have to change to protect against them. The evolution of plate armor can also be seen as following changes in fashion: styles of armor closely mirrored civilian dress and represented one way the chivalric elite could distinguish itself from those only pretending to that status. In fact, the various manuscripts of *The Flower of Battle* can be dated by the style of armor depicted. A third interpretation suggests that these changes were driven by technology: by the mid-fourteenth century, thanks to the improvement of the blast furnace, iron pure enough to be pounded out into armor plates without cracking could be produced on an industrial scale. Key to this technological advance was both water power to turn the waterwheels that moved trip hammers and mechanical bellows and also an avid demand from the military elite—which is why Milan, with its water resources and access to transalpine trade routes, was Europe's single biggest armor-producing center.

(Combat with Pollaxe, fol. 36v, detail)

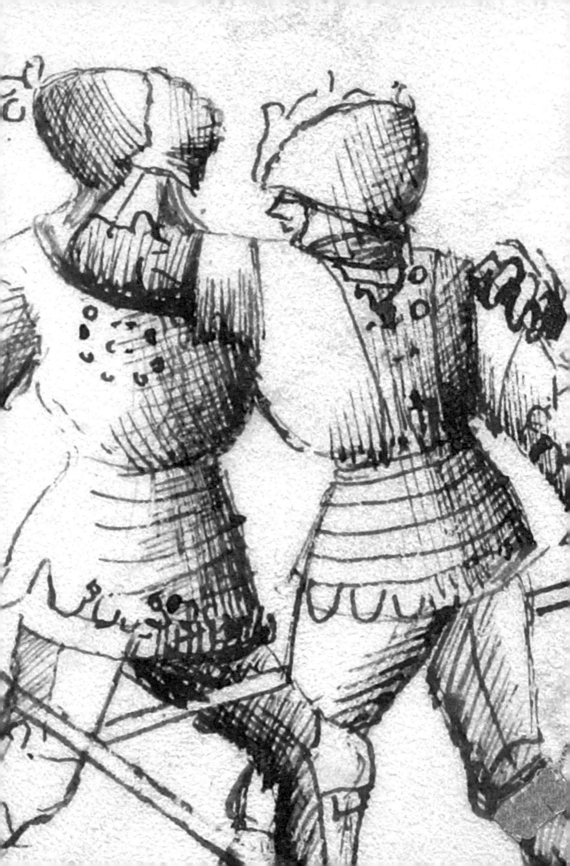

Moy femo ·by· Magior che sauemo ben
armezare, E zasschuno de noy quellarte soy
ben fare. E de arme manuale auemo bon paso
de tagli e de punte se defendemo sel zi faldo.
Jo son posta breue la sspentina meglor de le
altre mi tegno, A con duro una punta ben gli
parum la segno.

Kosta di uera crose che contra tuostio sfare, in mi le
toy punte no pon entrare. De tu me contro i lo passare che
faro, e de punta te feriro, senza fallo, che tu de altre guar
die passo mi pon fare, tanto so bene lo armizare che no pos
so fallire lo morsure, che in lo passar e in lo morsar
e in lo ferire, larte uole questo a non fallire.

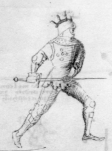

· Posta Breue la serpentina ·

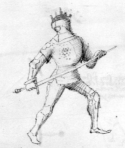

Posta de uera crose ·

Sompno serpentino son lo soprano, eben
armado grande punte zetto sotto mano, che
son in certo, e torno al piano. Una forte punta
ti butiro ou lo passare. Ella e mia arte che la so
ben fare. Di tor tagli no me curo mente tanto
so in larte, che de grande punte io ti daro gran pre.

Porta di ferro la mezana son chiamata, p che larme
e senza esfazo le punte forte. E passaro fora d strada
ou lo pe stancho, e te metero una punta i lo uolto, o uero
che ali la punta ecu lo taglio enstra li toy brizzi mitraro
p modo che io te metero in ligadura mezana, in quella che
denanzi pinta e nomenada.

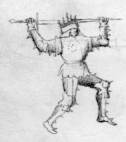

Sonno serpentino lo soprano ·

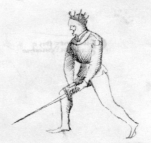

Porta de ferro la mezana ·

72 Defeating plate armor required a specialized sort of fighting, and Fiore explains how to use the
sword in a variety of ways: as a lance to penetrate the adversary's defenses, as an axe to stun him,
and as a lever to execute joint locks. Fiore gives six *poste* for fighting in armor. These drawings
illustrate, left to right and top to bottom, the "short serpent," "true cross," "high serpent" (detail
opposite), and the middle iron gate (see p. 55), which can be used in or out of armor. (fol. 32v)

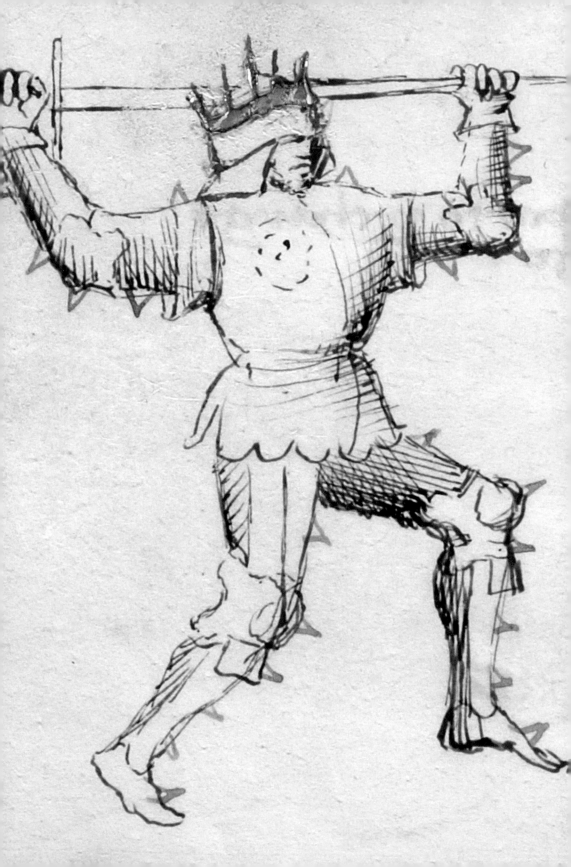

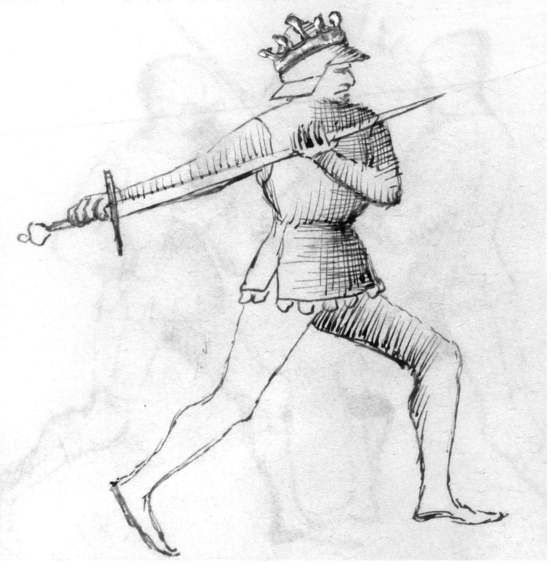

Posta Sagittaria

74 The "archer's position" above uses the sword like a bayonet. The weak points at the elbows, armpits, and neck, where the opponent was usually covered only in mail, were favorite targets for thrusts. (fol. 33, detail)

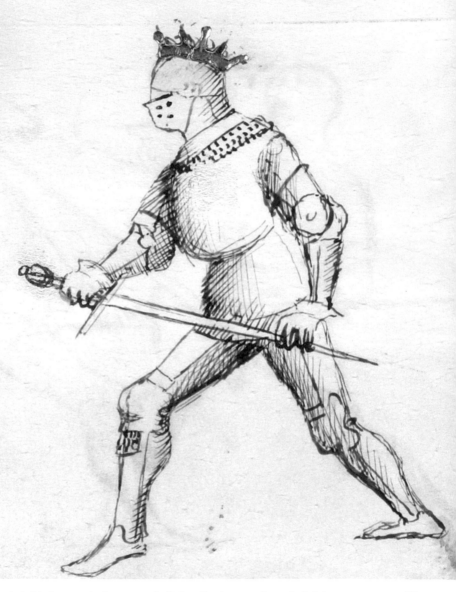

Posta de crose bastarda .

One rationale behind armor design was to limit the effectiveness of certain fighting techniques. The master showing the "bastard cross" is dressed in the latest style; his helmet, the newly invented great bascinet, protects his vulnerable neck with steel plates, albeit at the cost of reduced mobility. (fol. 33, detail)

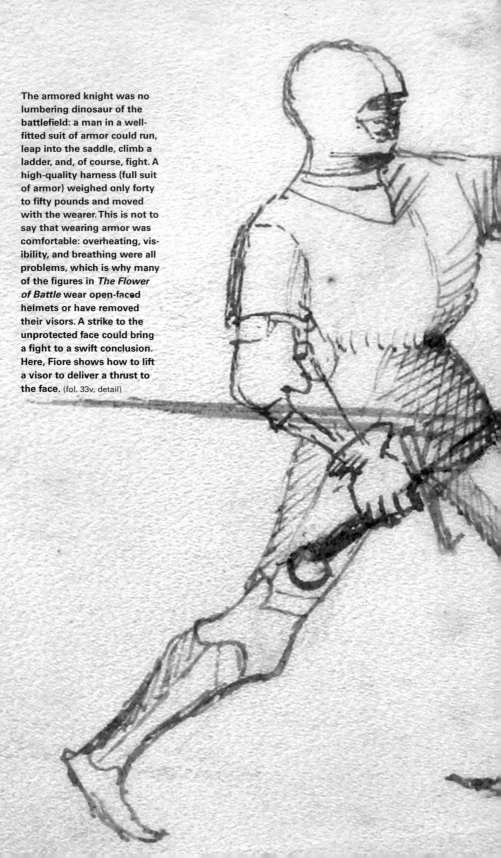

The armored knight was no lumbering dinosaur of the battlefield: a man in a well-fitted suit of armor could run, leap into the saddle, climb a ladder, and, of course, fight. A high-quality harness (full suit of armor) weighed only forty to fifty pounds and moved with the wearer. This is not to say that wearing armor was comfortable: overheating, visibility, and breathing were all problems, which is why many of the figures in *The Flower of Battle* wear open-faced helmets or have removed their visors. A strike to the unprotected face could bring a fight to a swift conclusion. Here, Fiore shows how to lift a visor to deliver a thrust to the face. (fol. 33v, detail)

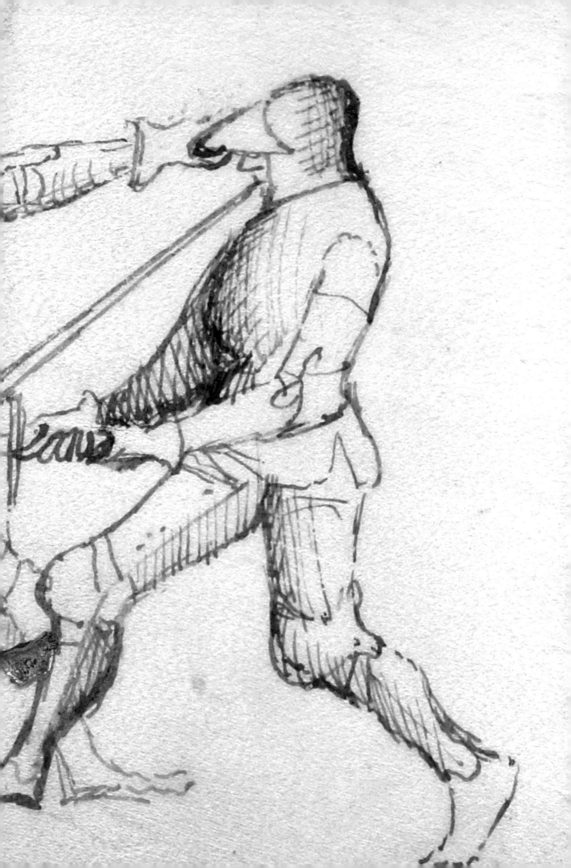

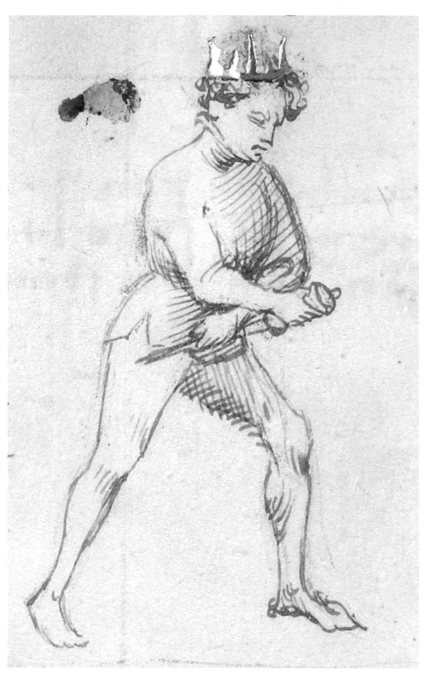

78 Even though this figure in "half iron gate" position (from the section on dagger defenses) is shown without mail or plate armor, Fiore notes in the accompanying caption that the defense is better executed with such protection. Suggestions like this for armored fighting occur throughout the manuscript. (fol. 9, detail)

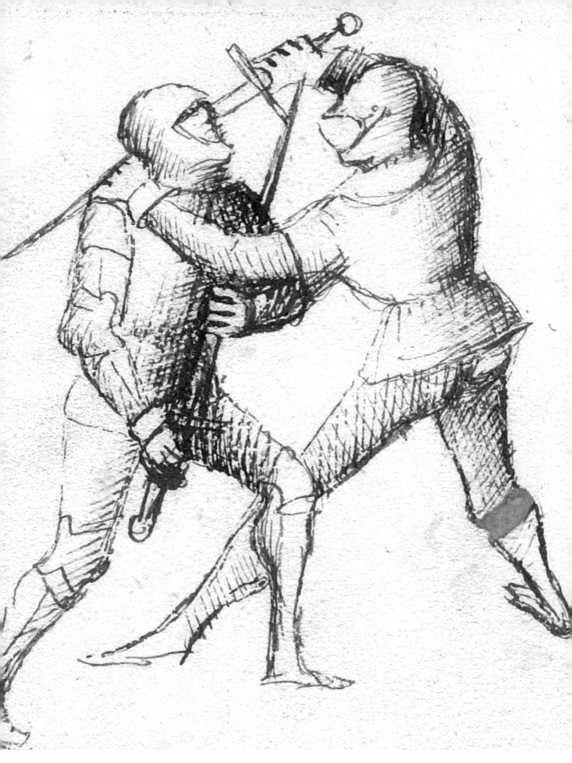

The same martial principles apply throughout the manuscript. Here, an armored combatant uses his sword as a lever to wrestle with an adversary, hoping to pull him down. A foe thrown to the ground could then be pinned and dispatched at leisure. (fol. 34v, detail)

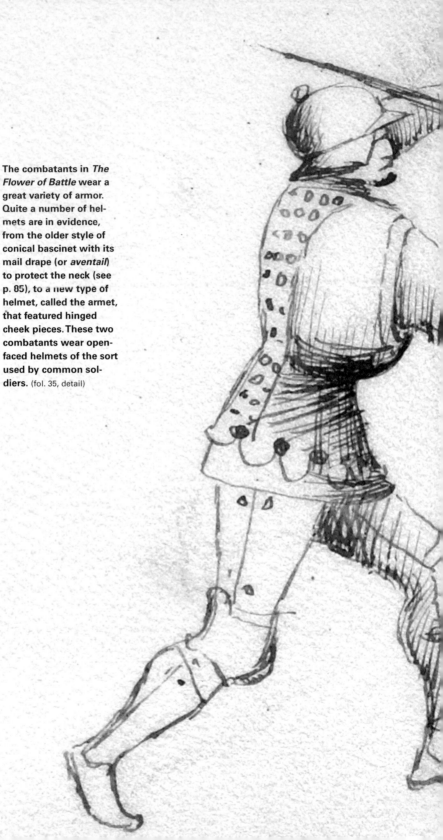

The combatants in *The Flower of Battle* wear a great variety of armor. Quite a number of helmets are in evidence, from the older style of conical bascinet with its mail drape (or *aventail*) to protect the neck (see p. 85), to a new type of helmet, called the armet, that featured hinged cheek pieces. These two combatants wear open-faced helmets of the sort used by common soldiers. (fol. 35, detail)

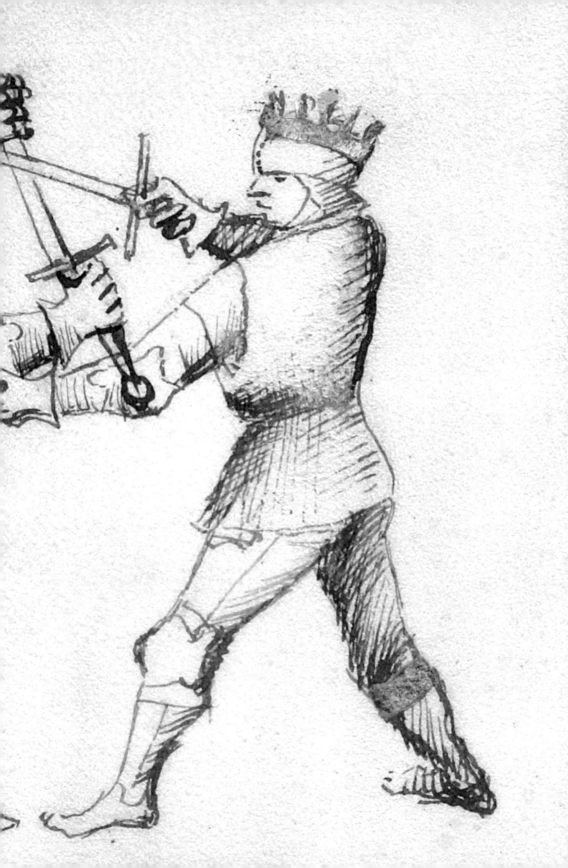

Hafted Weapons

The century before Fiore dei Liberi wrote *The Flower of Battle* had seen a radical shift in tactics, as bodies of well-trained infantry began to challenge the feudal elite for battlefield supremacy. Used individually or in a disciplined group, a weapon mounted on a wooden haft could reach far enough and hit hard enough to threaten even a mounted knight. At battles such as those that took place at Courtrai in 1302, Bannockburn in 1314, Crécy in 1346, and Poitiers in 1356, foot soldiers armed with polearms and with the English longbow defeated expensively equipped cavalry in what has been called "the military revolution of the fourteenth century." Rulers began to realize that hiring many foot soldiers was more economical and often more effective than concentrating solely on an army of mounted knights. Medieval men-at-arms, being pragmatic warriors at heart, were quick to adapt to these new realities and began to utilize new weapons and techniques.

A favorite tool was the poleaxe, which was used not only in war but also in judicial duels and in the newly fashionable tournament combats on foot. It was considered as noble a weapon as the sword. Essentially a two-handed man opener, it featured a lobster-mallet head equally suited to cracking skulls and armor. This head was mounted opposite a sharp hook or axe-head that could be used both for piercing or pulling an opponent off balance—or off his horse. Spikes on both the head and tail end made the weapon a quadruple threat.

(Combat with Pollaxe, fol. 36v, detail)

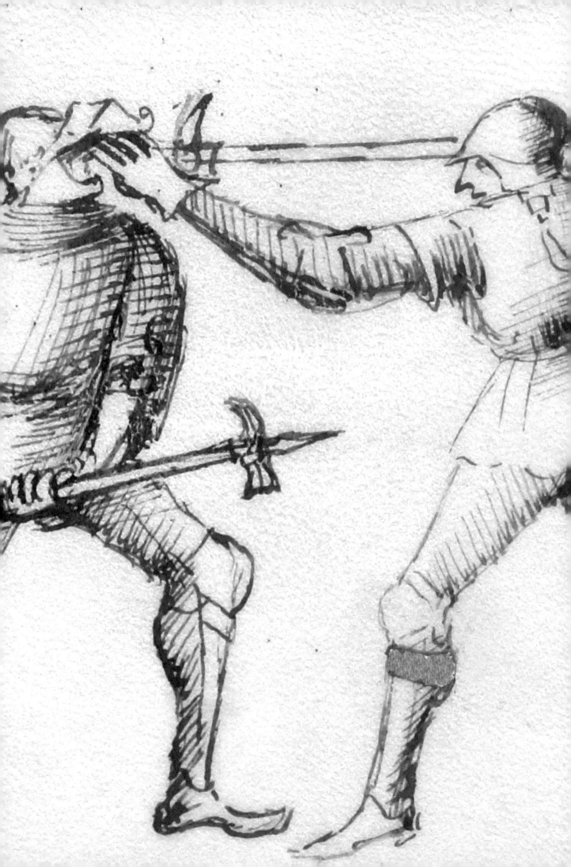

porta sua lanza a meza lanza / L'altro por
a lanza restada a tutta lanza / Lo terzo lo
inzare cu sua lanza. E sie de patto che nisi
debia fare piu d'un colpo p homo. Anchora
fare a vno a vno.

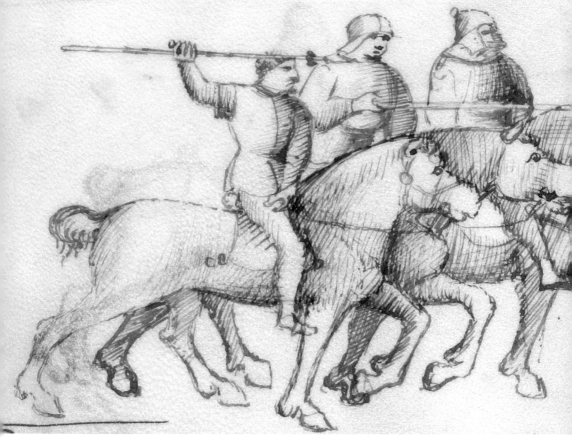

84 The spear—one of the oldest and most common weapons known to humanity—was also
a favorite of Fiore's; he advocated using it both on foot and on horseback. He shows how it
can be utilized not just for thrusting but also for parrying the enemy's attack in the manner

in dente di cenghiaro son presto p[er] as[f]
Quando la lanza contra me vignira p[er]
uero de mane zitada / subito io sch[i]uo
zoe che io arresto lo pe dritto fora de s[trada]
e cu lo stancho passo ala trauersa reba[tto]
la lanza che mi uene p[er] ferire. Si che [a]
una no poria fallire. Questo ch[e] io f[azo]
la ghiauarina / cu bastone e cu spada [faria]
Ella deffesa ch[e] io fazo contra le lanze [cu]
spada e cotra bastone quello faria l[i]
zoghi che sono dredo.

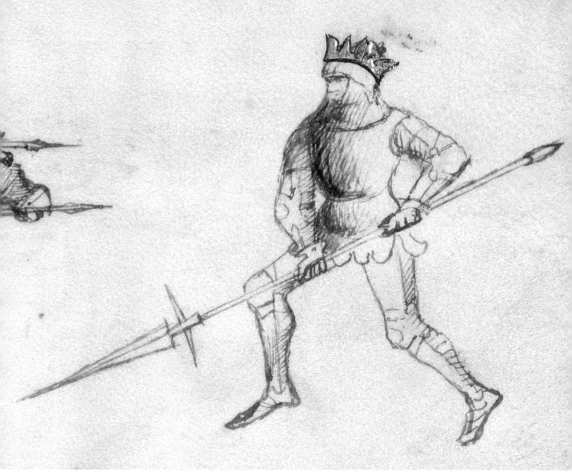

of a sword or a stick. A particularly Italian variation of the spear was the *ghiavarina*, which featured two sharp spikes mounted at an angle to a broad spearhead. Here, Fiore shows this weapon being employed effectively against mounted knights. (fol. 46, detail)

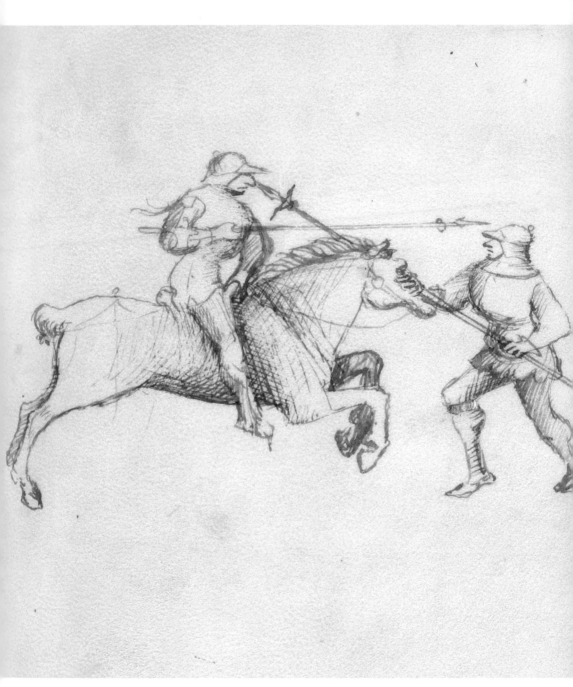

86 **From either side, and with either end of the weapon, a student can deflect an oncoming lance while stepping away from the attack and striking with his *ghiavarina*. The artist's careful observation of nature and quick, sure strokes of the pen convey the movement of the charging horses' legs at different moments of their stride.** (fol. 46, detail)

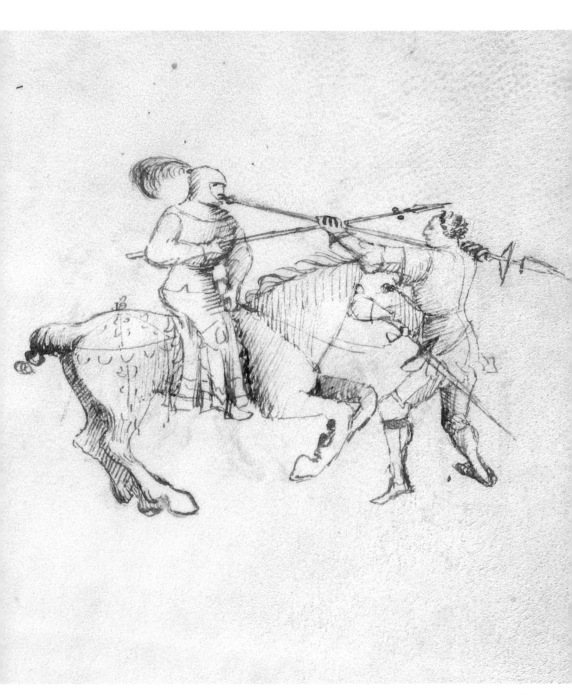

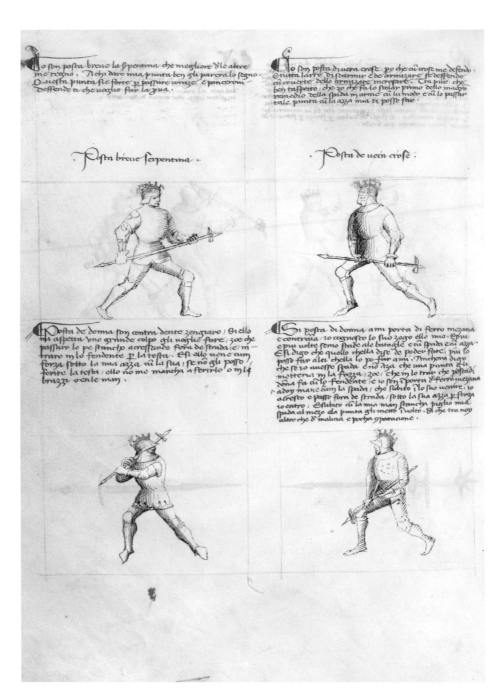

Posta breue serpentina .

Posta de uera crose :

88 The sword positions (see p. 72) also serve for the poleaxe, as shown here, left to right and top to bottom: the short serpent, true cross, woman's *posta* (detail opposite) and middle iron gate. (fol. 35v)

Above is the long tail *posta* with the axe; opposite, the window *posta*. (fol. 36, details)

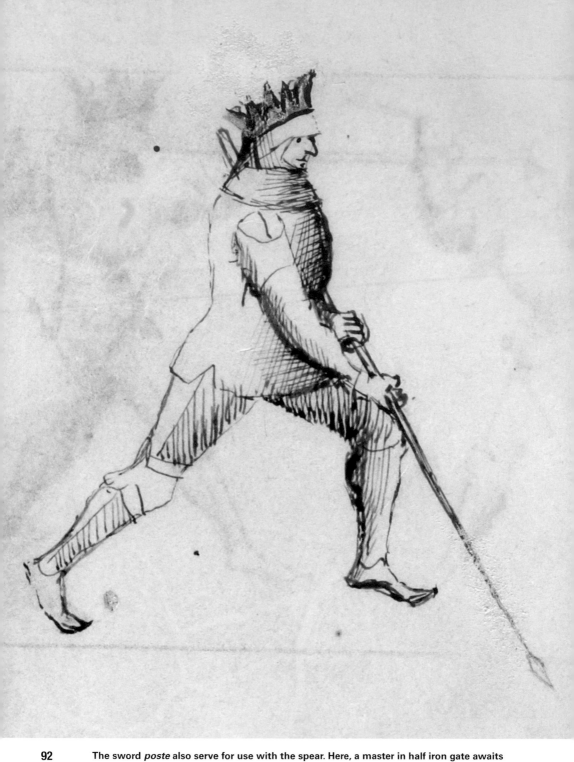

92 The sword *poste* also serve for use with the spear. Here, a master in half iron gate awaits his less-skilled foe (on the right). In one action, the master will bring up his spear while stepping forward, defending himself, and striking the adversary in one action. (fol. 39, detail)

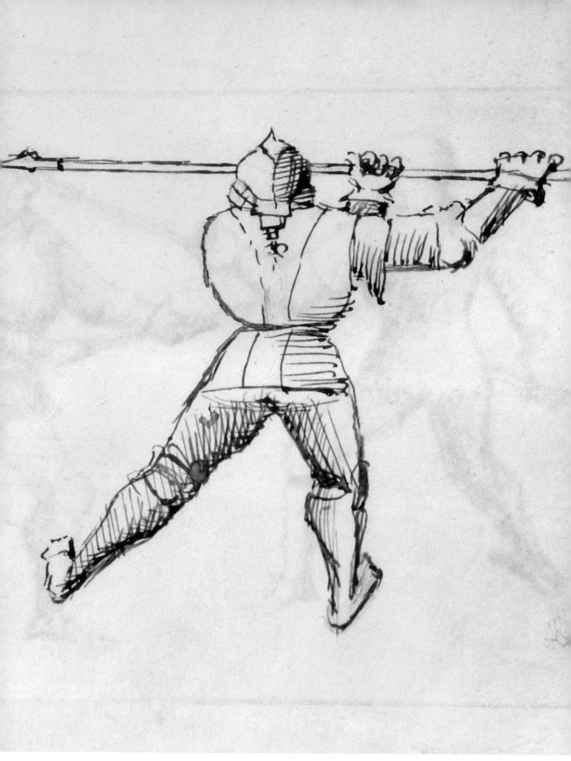

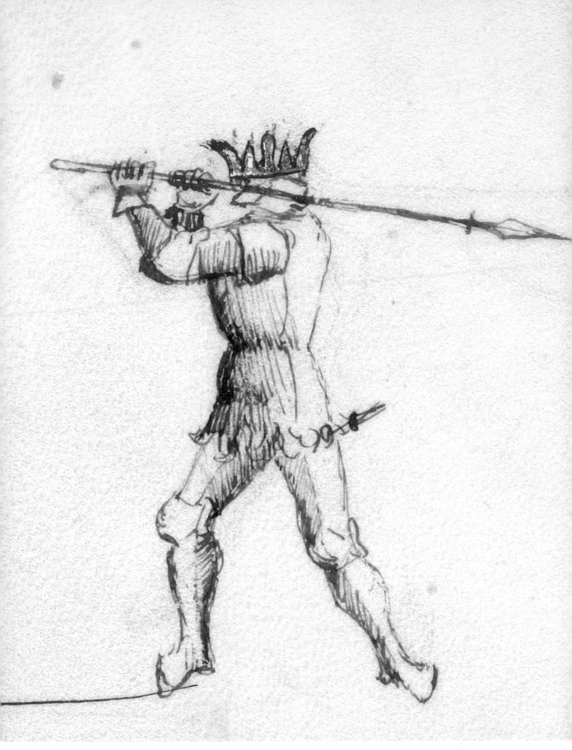

94 Key to Fiore's art is a mastery of timing, distance, and opposing the enemy's strength most efficiently. A skilled longsword fencer frequently steps off the line of the attack to parry or counterattack. The same is true with the spear in window *posta* (above). This play will end with the master beating aside the thrust his adversary is threatening (opposite) and then hitting him. (fol. 39v, detail)

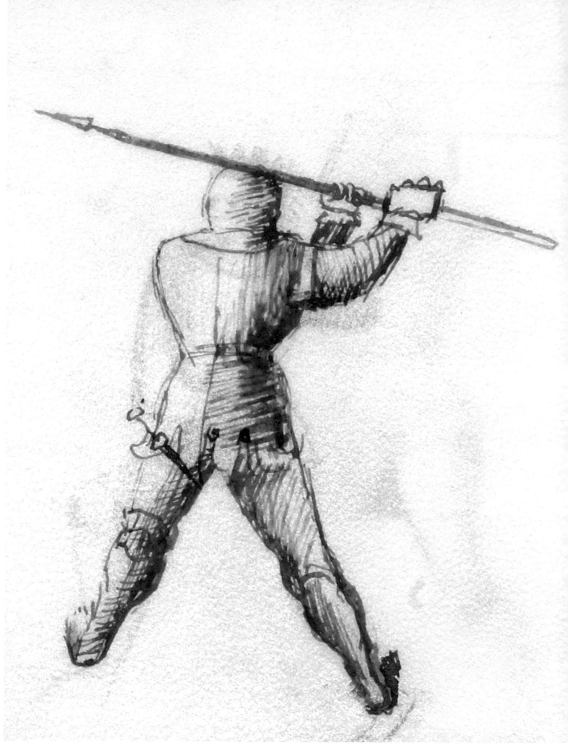

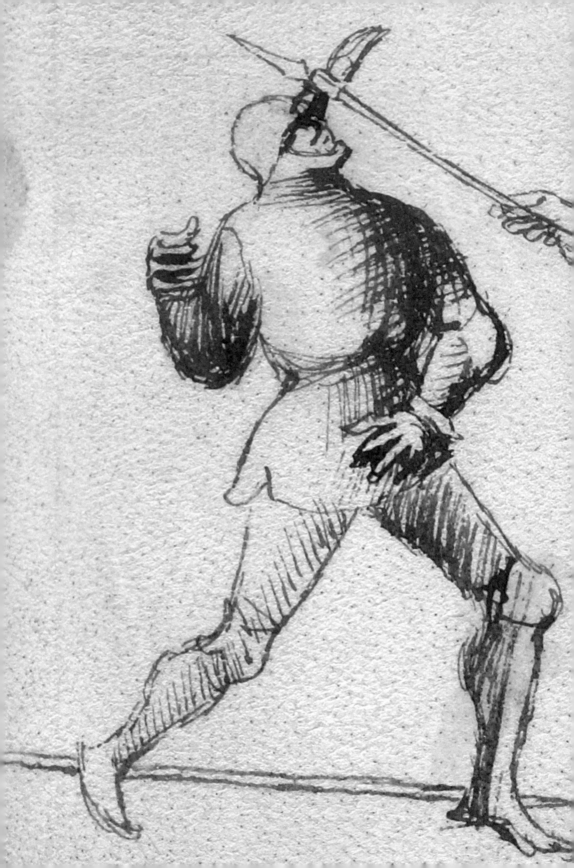

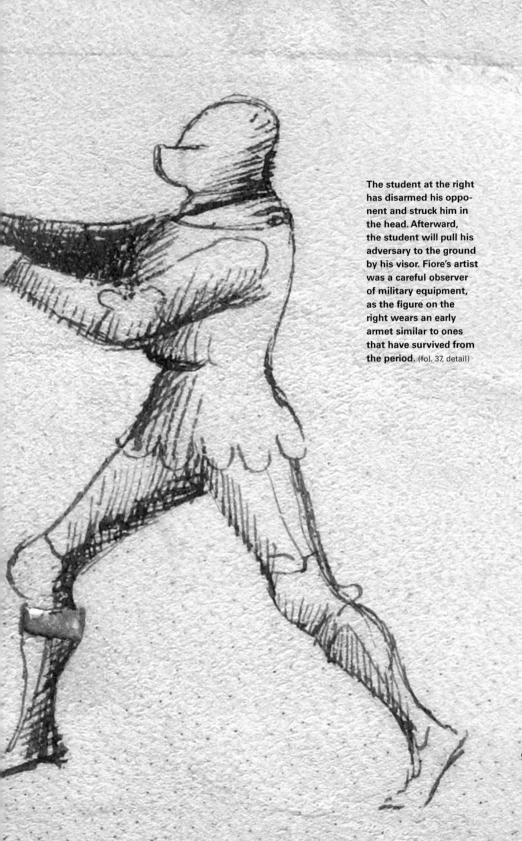

The student at the right has disarmed his opponent and struck him in the head. Afterward, the student will pull his adversary to the ground by his visor. Fiore's artist was a careful observer of military equipment, as the figure on the right wears an early armet similar to ones that have survived from the period. (fol. 37, detail)

Equestrian Combat

Even if the battlefield was becoming increasingly dominated by infantry, the self-image of the medieval military class was still that of the mounted combatant, and cavalry warfare remained a particularly dominant feature of warfare in Italy. To acquit oneself well in this pursuit required not only a good horse but constant practice from an early age. To fight on horseback, a man-at-arms needed to be able to rely on his horse for instantaneous response in the same way that he could rely on his own body. Geoffrey de Charny, a French near-contemporary of Fiore, asked the hypothetical question if it were better to engage without spurs or without a sword; the implication was that a knight was as equally disadvantaged if he could not control his steed as he was without a weapon.

The medieval warhorse was no clumsy, hulking draft horse but a superbly trained martial athlete. In fact, medieval warhorses were rather small by the standards of modern sport horses, standing about fourteen to fifteen hands (56–60 in. [1.4–1.5m]) at the shoulder—though they were powerfully built. A well-bred, well-schooled mount could cost many times the average man's yearly pay. The rather severe mouth bits used at the time would have required a light, skilled hand, and a well-trained horse would have been able to respond sensitively to the rider's leg commands. Indeed, it is from the maneuvers used in schooling the medieval fighting horse that the modern art and sport of dressage arises.

(Equestrian Combat with Lance, fol. 41, detail)

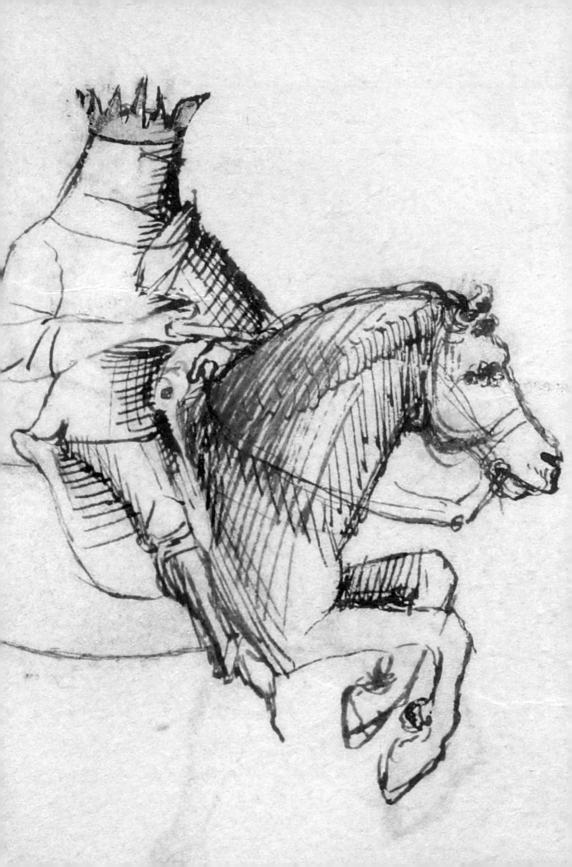

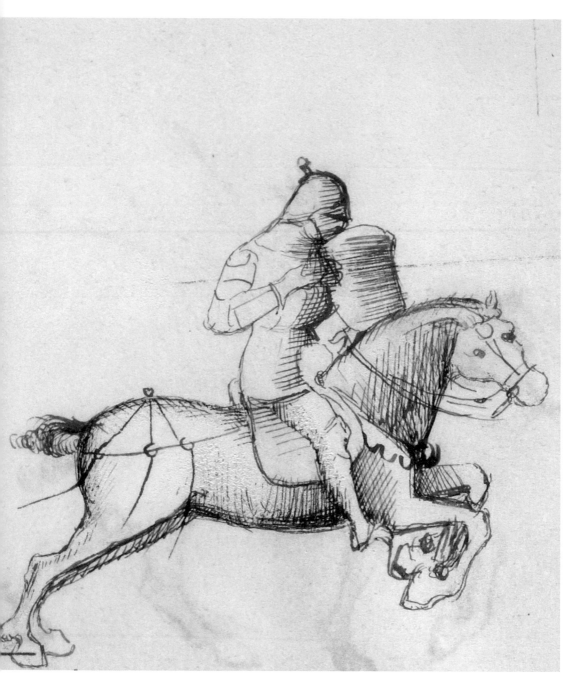

Most of the same techniques that were used on foot could be used on horseback, and Fiore shows wrestling, sword fighting, and, of course, jousting with a lance. (fol. 41, detail)

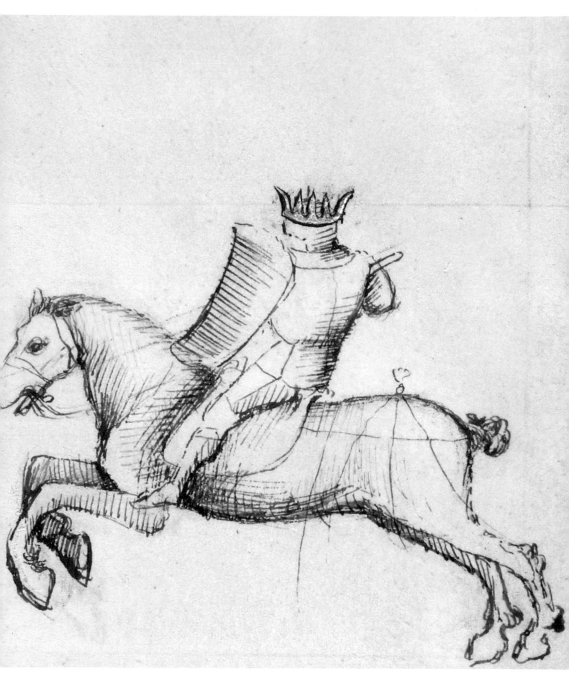

Likewise, the same tactics and techniques that one could use on foot could be used when mounted. The master above will use boar's tooth (see p. 57) to deflect his adversary's lance and then drive his own point home. (fol. 41, detail)

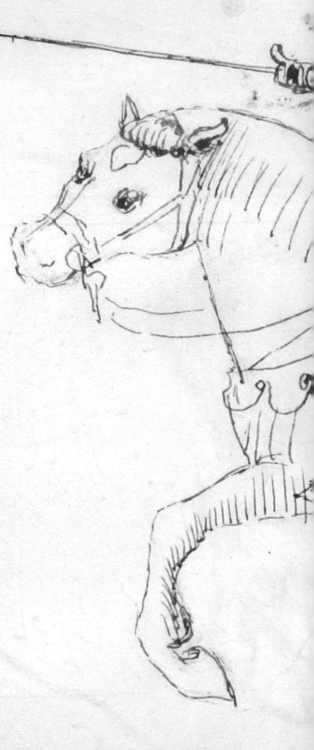

By carrying his lance with his right hand and under his left arm, this counter-master makes it difficult for an opponent to beat it aside. Combat on horseback was aided by the typical war saddle, which featured a high pommel (hidden here by the left hand) to protect the rider's groin and a high cantle (back) to ensure he kept his seat. The artist's keen eye for detail extends to the horse's gait; it is easy to see that this technique is being done at a walk.

(fol. 42v, detail)

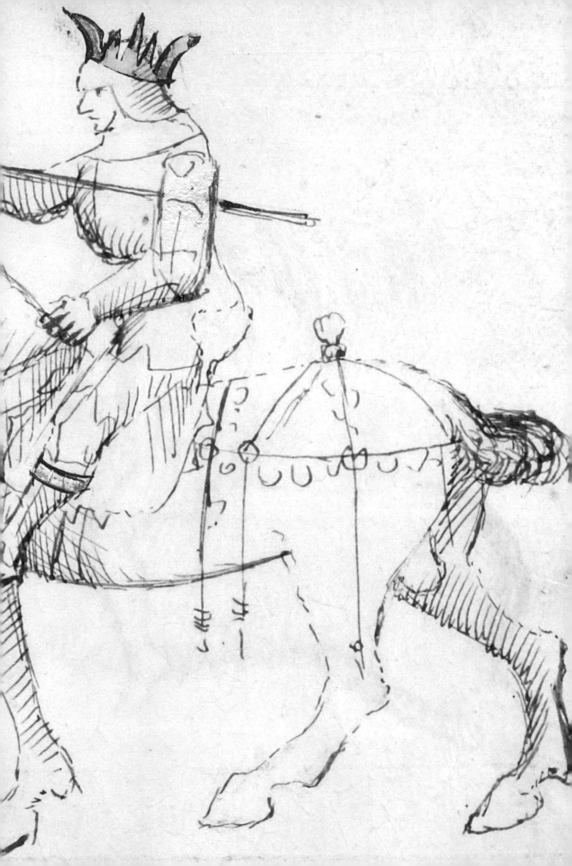

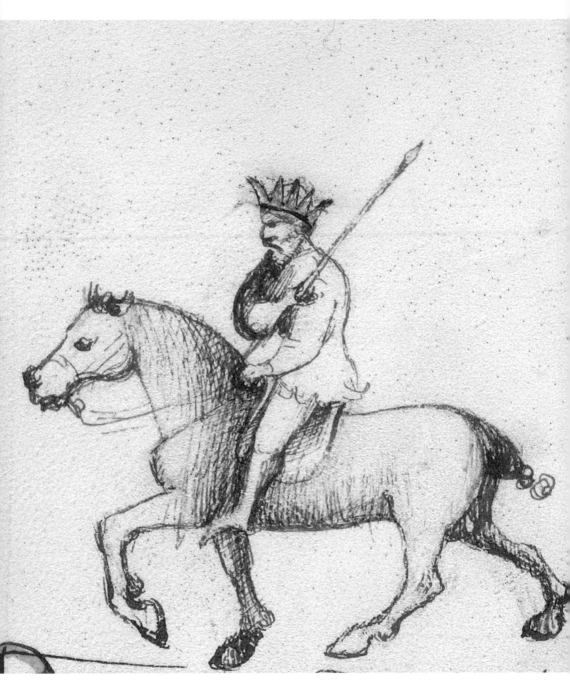

104 Two examples of how the same positions and techniques can be used with different
weapons show a spear and sword in left woman's *posta*, ready to deflect an attack.

(fol. 41v, detail, above and fol. 42v, detail, opposite)

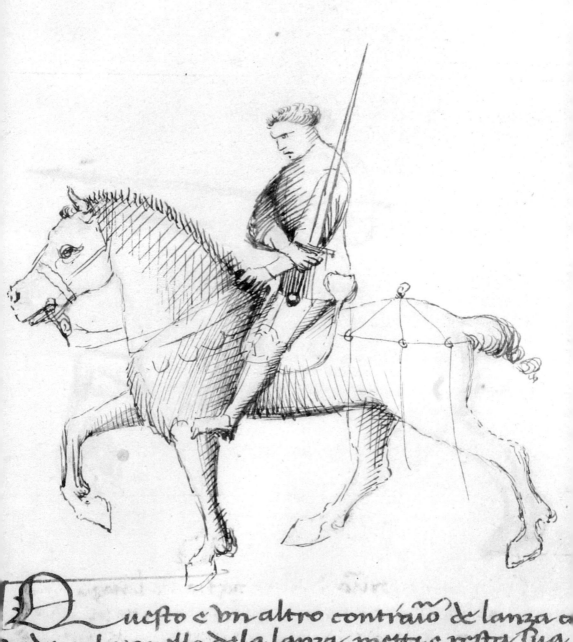

Ꝺ uesto e un altro contrario de lanza e
pada / che quello dela lanza mette e resta sua
otto lo suo brazo stancho p che no gli sta rebatu
ua lanza . E p tal modo pora ferir cu sua lanꝫ
ella spada .

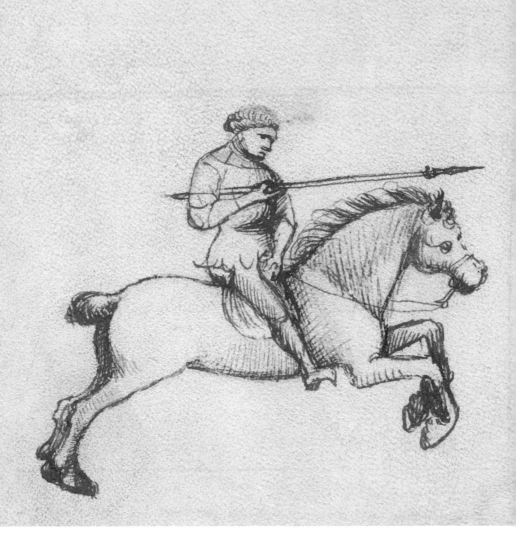

bo cauallo corente / e sempre ua buttando le
punte aim la sua lanza dredo de si p ferir lo
compagno. E si ello sauoltasse dela parte dritta
bem poria intrar in dente di zenghiaro cu sua
lanza / ouero in posta di donna la sinistra / e
rebatter e finire come si po far in lo pmo e in lo
terzo zogho de lanza.

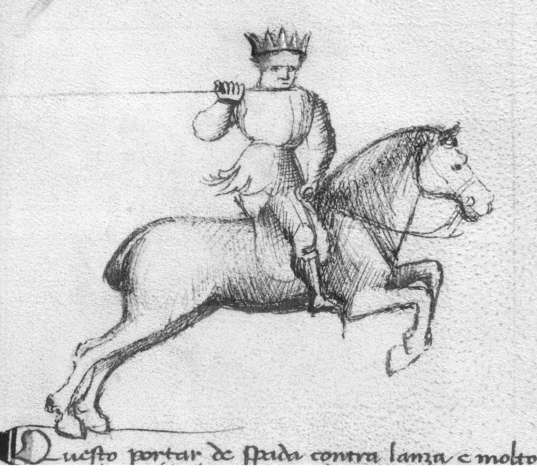

Queſto portar de ſpada contra lanza e molto

Holding his lance over his shoulder, a skilled rider can fend off an attacker while fleeing. **107**
Here the artist successfully captures the sense of horses in flight. (fol. 42, detail)

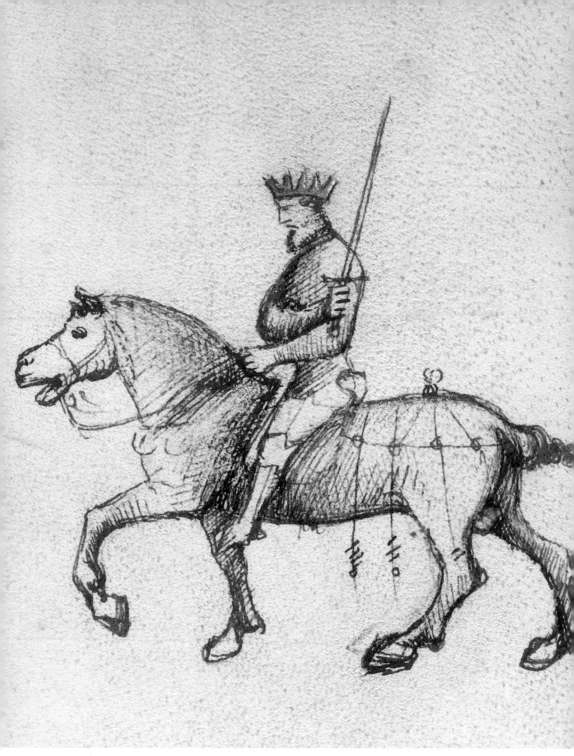

108 This crowned master waits to defend himself against a lance charge. The artist's close observation of equine anatomy is seen in details such as the horse's hooves and powerful **legs.** (fol. 42, detail)

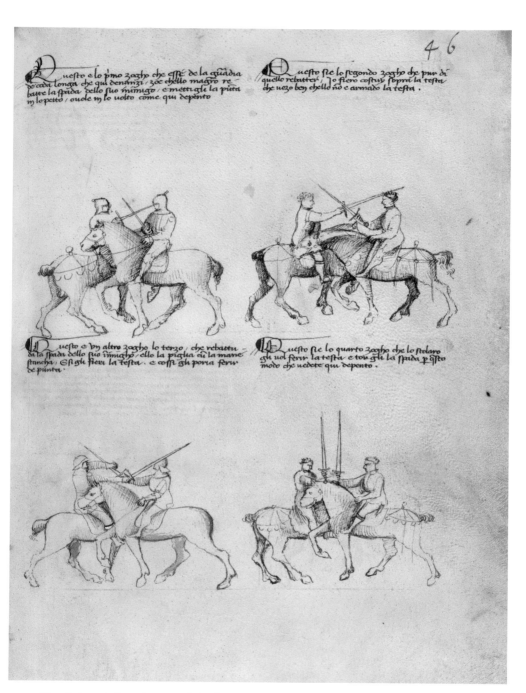

Mounted combat requires superlative horsemanship. A rider must be able to position and control his mount as an extension of his own body, as seen in these four illustrations. (fol. 44)

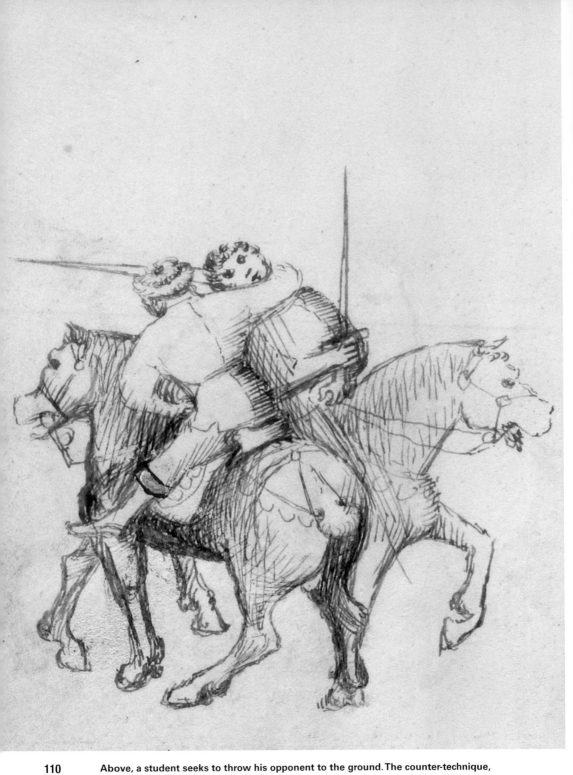

110 **Above, a student seeks to throw his opponent to the ground. The counter-technique, opposite, is a blow to the leg with a sword.** (fol. 44v, details)

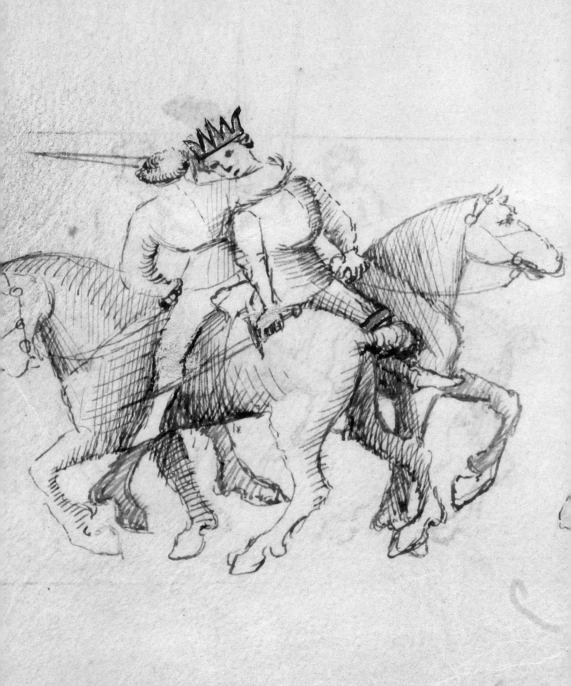

uesto e zogho de abrazare zoe zogho e
brazi, e si fa p tal modo. Quando vno ti fuzi
e dela pte stancha tu gli vien apresso, Cu la ma
dritta tu lo pigli in le sguanze dello bacinetto, e
se ello e disarmado, p gli caugli, ouero per lo
brazo dritto p dredo le soy spalle, p tal modo fa
ralo ruisare, che in terra lo farai andare.

112 **Riding up behind an adversary's vulnerable left side, a student grabs him with his right hand in an effort to drag him from the saddle.** (fol. 45, detail)

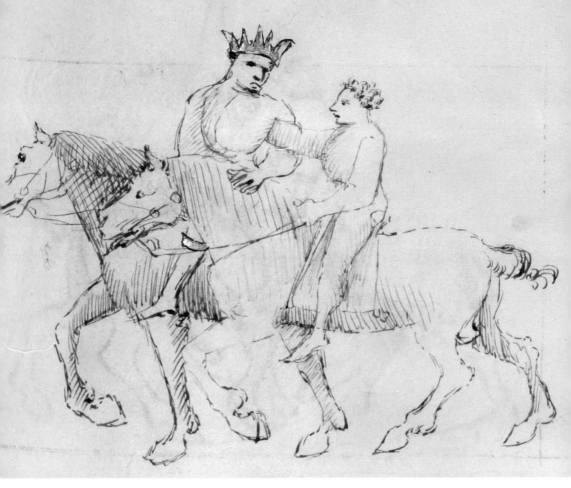

uesto e contrario del zogho ch[e] denanzi
e cual p[er] tal modo / questo contrario cu[m] tal p[re]sa se fa
de subito quando ello p[er] dreto lo piglia / La man de la
riglia debia subito scambiare / e cu[m] lo brazo staracho
tal modo lo de pigtare .

The supposed victim's counter is to pin the attacker's arm and turn the tables by pulling
him off his own horse. A good seat and a well-trained steed are critical for doing this
successfully. (fol. 45, detail)

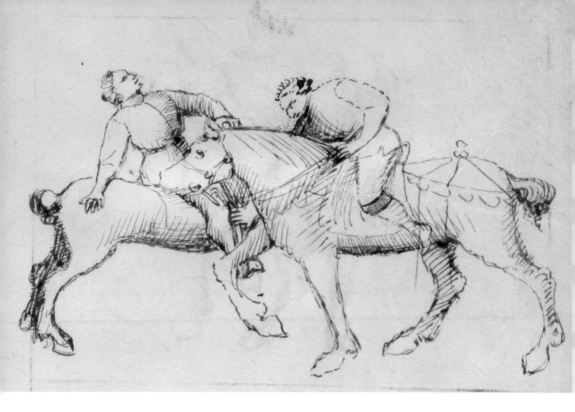

These two images show another technique and counter: above, the attacker tries to overthrow his opponent by lifting his foot and stirrup (fol. 45, detail), but, below, the defender counters by throwing his arm around the attacker's neck. (fol. 45v, detail)

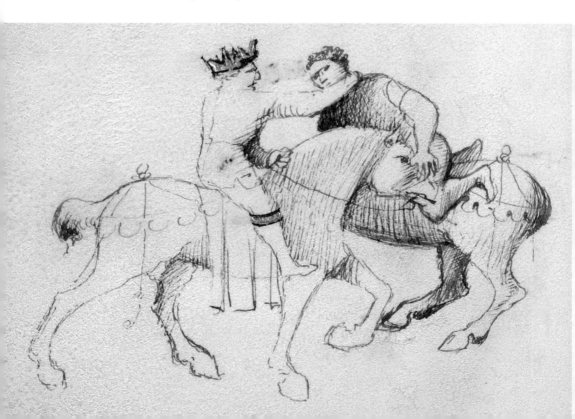

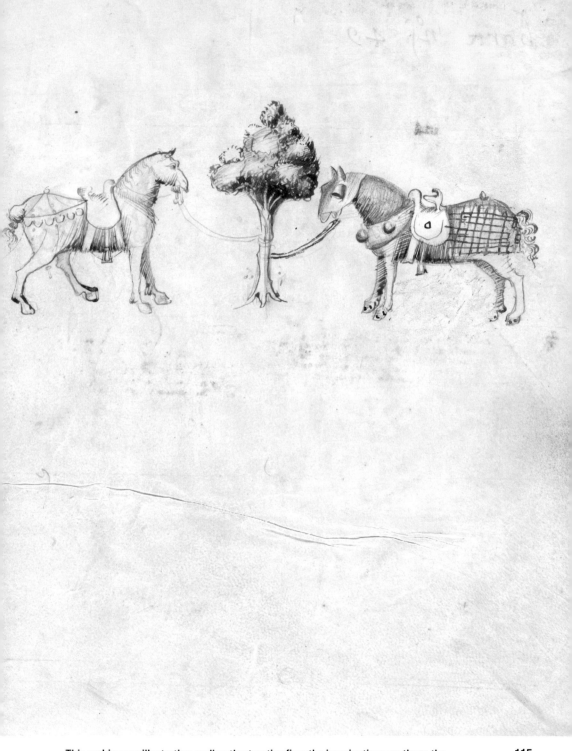

This ambiguous illustration ending the treatise fires the imagination: are these the
horses of the vanquished? Are they resting after a hard day of training while their mas-
ters refresh themselves? Or did the artist simply enjoy drawing horses? (fol. 47)

Dirty Tricks and Improvised Weapons

Scattered throughout Fiore's book are various dirty tricks and tactics for improvised weapons. As in his self-defense scenarios, Fiore prepares his student for when the combatants' skills or weaponry are not equal—both to seek his own advantage and to minimize the adversary's. Some of these techniques, such as blinding powders and polearms with weights and ropes to wind around the foe, are quite ingenious, if seemingly impractical. Others make use of objects at hand. On the battlefield or in an unexpected ambush, the medieval warrior had to make use of whatever was in reach—or his own hands and feet—to emerge victorious.

In the illustration at right, one of Fiore's masters uses a polearm with a saltshaker head to throw a blinding powder into the enemy's eyes. Fiore goes so far as to specify what the material should be made of: powdered thyme extract and *fior di preta*, a cosmetic that was used in makeup to produce swelling (and thus decrease the appearance of wrinkles). As unchivalrous and perhaps overly complicated as this may seem to modern eyes, Fiore's first priority was to ensure that his student would be prepared for any situation.

(Combat with Implements, fol. 37v, detail)

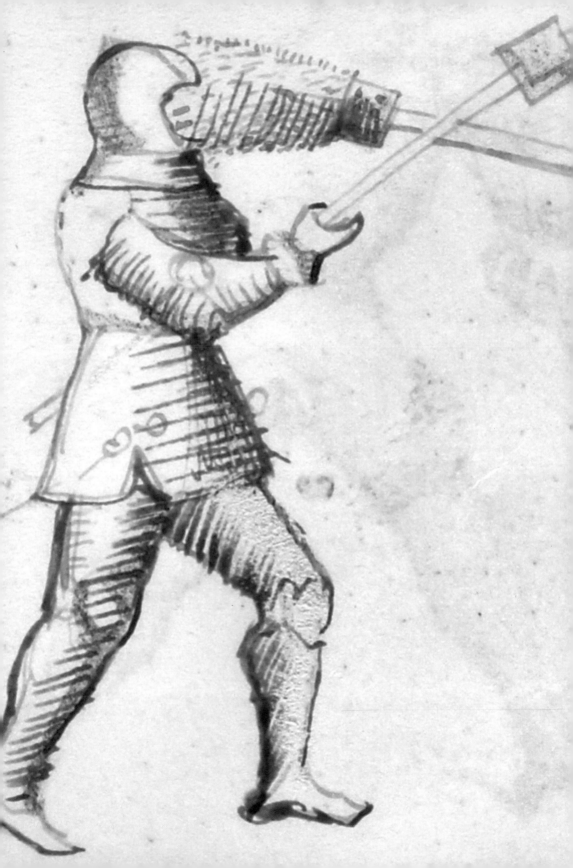

Queſto magre ſpetta queſto doi cū le lor lanze
lo pmo uol trar cū la punta ſopͥ man, Glattro uol
trare ſotto man. queſto ſi uede. Lu magͥo che aſ-
petta cū lo baſtone ecū la daga, quādo vno di queſti
gli uol trare cū ſua lanza, lo magͥo piega lo baſton
ĩ uerſo pte dritta zoe quaſi ĩ tutta porta di fͬo
uoltando la pſona, non amouendo gli pie ne lobaſt
di terra. Grimane lo magͥo ĩ guardia. Ecome
uno di queſti tra, ello rebatte la ſua lanza cū lo baſt
ne, ecū la daga ſcilo biſogna a man ſtancha, e
cū quello rebatter ello paſſa e fieri. Gqueſta e la
ſua deſſeſa come trouerete dredo queſte dot ð lanze

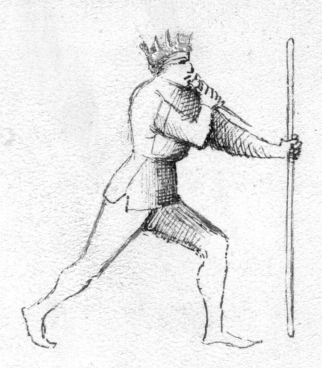

This scenario does not illustrate a two-on-one situation; rather it explains how Fiore's
combative principles could be used in self-defense no matter what the angle of the
enemy's attack. This master is armed with both a dagger and a staff—perhaps a spear,

Eramo ambi doi disposti d' ferire questo magro
ma segondo lo so ditto nõ poremo far niente. Saluo
se noy no linganamo p questo modo zoe noi uoltere
gli ferri de le lanze di dredo / e trauemo cũ lo pedale
de la lanza . E quando ello rebattera lo pedale d' la
lanza / noy uolteremo nostre lanze / e feriremo lo
de l altra pte cũ gli ferri d' le lanze . E questo fa
lo suo contraio .

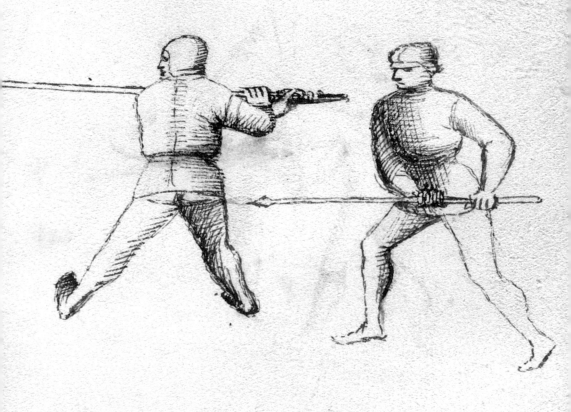

broken polearm, or simple walking stick. Even with this improvised defense, however, he **119**
can deflect and strike. (fol. 31, detail)

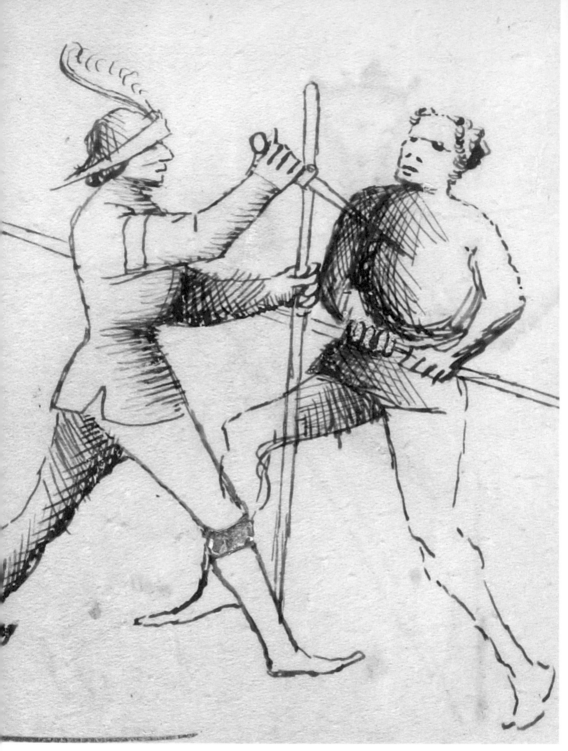

120 Having parried an attack (see pp. 118–19), the defender can now bury his dagger in the
attacker's chest. (fol. 31v, detail)

Questo magistro fara deffesa cu questi doi bastoni contra la lanza in questo modo, che quado quello de la lanza gli sara apresso p trare, lo magistro cu la mane ritta tra lo bastone p la testa di quello de la lanza. E subito cu quello trare, ua cu laltro bastone a la coista ela lanza, e cum sua daga gli fieri in lo petto segodo che depento a qui dredo.

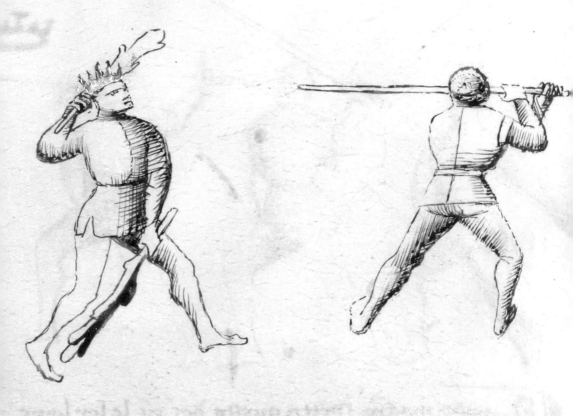

This master has picked up two sticks with which to defend himself. His dagger (not shown but described in the text) remains sheathed in his belt. He will throw the stick in his right hand at the adversary's head while deflecting with the other and then immediately draw and strike with his dagger. (fol. 31v, detail)

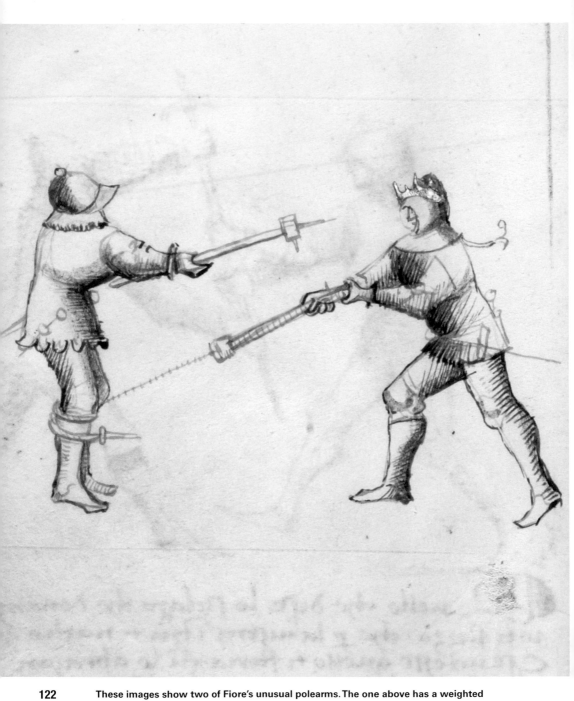

122 These images show two of Fiore's unusual polearms. The one above has a weighted head on a lanyard to wrap up the adversary, pinning his arms or legs; on the opposite page is a polearm with blinding powder. (fol. 37v, details)

uegno afare / la azza me di danno e niente piu n
le. E se io fiero lo pmo colpo chio fazzo / tutte le a
ne mrtuale io cauo dimpazo. E se son cũ bone a
acompagnada / p mia deffesa piglio le guardi
ſtatue de ſpada. Signore nobiliſſmo O
o Marcheſe / aſſay choſe ſono in queſto libro che
le maltue nõ le fareſte. Ma p piu ſauere / p
di uederle.

Queſta e la poluere che uai in la azza penta
piglia la latte delo titimallo / e ſeccalo al ſole
forno caldo e fane poluere / e piglia di qui
poluere vnõ .ij. e vna vnza de poluere d' fia
reda / e meſtola in ſembre. e queſta poluere
etter in la azza qui de ſopra / beñ che ſe po
ogni rittorio che ſia fino / che beñ ne trouen
fino in queſto libro.

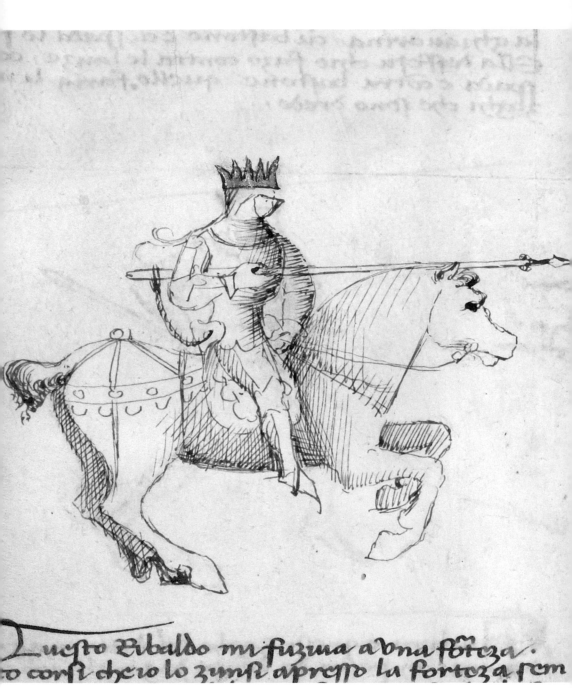

124 A tactic to use on horseback is shown here: the master at the left has a rope tied from his saddle to the butt of his lance. He will strike his adversary, then hold out the spear to draw the rope taut and "clothesline" his adversary from the saddle. (fol. 46v, detail)

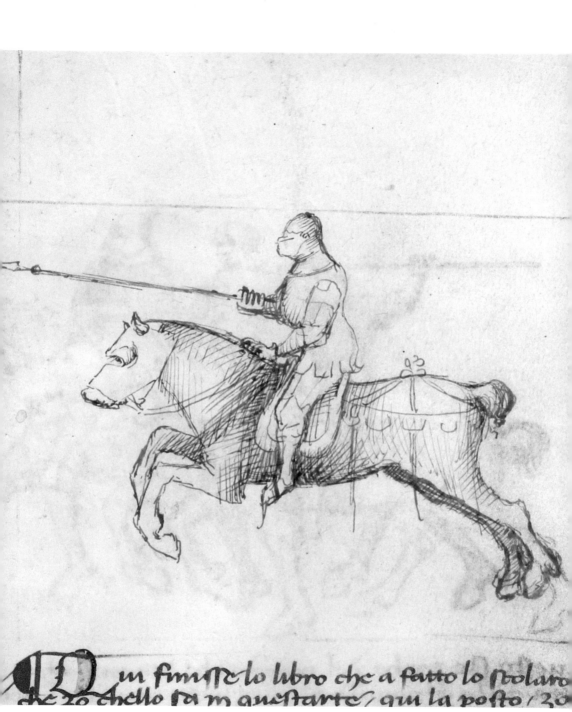

Qui finisse lo libro che a fatto lo scolaro
che zo chello sa m'anestarte; qui la posto / 30

GLOSSARY

abrazare Fiore dei Liberi's term for unarmed combat.

armet A type of helmet, originating in the early fifteenth century, with hinged cheek pieces.

aventail A mail drape on the bottom of a helmet to protect the neck.

bascinet A conical helmet popular in the fourteenth and early fifteenth centuries.

bole A soft clay used for affixing gold leaf to a manuscript illustration.

cantle The back part of a saddle. A high cantle can help the rider keep his seat.

condottiero (plural *condottieri*): An Italian mercenary or professional soldier from the late Middle Ages or Renaissance.

counter-master In Fiore's manuscripts, a figure who shows a counter to a student's technique.

dressage The historical and modern art and sport of training horses.

Fechtbuch (plural *Fechtbücher*): A record of European fighting arts from the medieval period. The term *Fechtbuch* is usually taken as referring to the German sources but can be broadly applied to the entire genre of medieval works on martial arts. Literally, a fencing or fighting book.

ghiavarina An Italian polearm with a broad, sharp spearhead for cutting or thrusting and two parrying spikes mounted at angles to it.

guardia (plural *guardie*): A ready stance or guard; used as a common term in Fiore's time for fencing stances or positions. See also *posta*.

hafted weapon Any weapon mounted on a long wooden pole, such as a poleaxe or spear; a polearm.

Historical European Martial Arts (HEMA): The modern discipline of reconstructing medieval and Renaissance fighting arts.

instabile Fiore's term for a *guardia* or *posta* through which one moves in a moment of transition.

joint lock A martial arts technique that uses leverage and mechanics to immobilize and/or damage an opponent's limbs.

longsword The knightly weapon of the fourteenth and fifteenth centuries, able to be used in one or two hands.

mail Armor made of an interlocked mesh of iron rings. Sometimes called "chain mail."

master (1) A martial arts teacher or fencing master. (2) In Fiore's manuscripts, a figure that shows a basic technique.

master-at-arms See **master**.

parchment Animal skin prepared for use as a writing material.

polearm See **hafted weapon**.

poleax (also *pollaxe*): A medieval and Renaissance hafted weapon with a cutting, crushing, and/or piercing head and sharp spikes on the head and tail end.

pommel The front of a saddle, which can protect the rider's groin as well as help him keep his seat.

posta (plural *poste*): Fiore's term for either a ready position or a stance, or a position through which one moves when performing sequential motions. He uses the term somewhat interchangeably with *guardia*, though the *guardie* seem to be more static in nature while the concept of *poste* indicates a more expanded and dynamic way of thinking about movement.

pulsativa Fiore's term for a *guardia* or *posta* from which a combatant can strike strongly.

quillons The cross-guard of a sword.

rondel dagger A medieval style of dagger, usually with a stiff, three-sided blade and sharp point.

stabile Fiore's term for a *guardia* or *posta* in which a combatant can await the adversary.

student (1) One who learns martial arts. (2) In Fiore's manuscripts, a figure who takes a master's place to show a follow-up technique.

tournament A usually friendly martial arts competition between two or more knightly combatants.

SUGGESTED READING

Agrippa, Camillo. *Fencing: A Renaissance Treatise*. Translated and with an introduction by Ken Mondschein. New York, 2009.

Anglo, Sydney. *The Martial Arts of Renaissance Europe*. New Haven, CT, 2000.

Carruthers, Mary J. *The Book of Memory: A Study of Memory in Medieval Culture*. Cambridge, UK, 1990.

Cavina, Marco. *Il duello giudiziario per punto d'onore. Genesi, apogeo e crisi nell'elaborazione dottrinale italiana*. Turin, 2003.

LaRocca, Donald J. *The Academy of the Sword: Illustrated Fencing Books, 1500–1800*. Exh. cat. New York, Metropolitan Museum of Art, 1998.

Muhlberger, Steven. *Deeds of Arms: Formal Combats in the Late Fourteenth Century*. Highland Village, TX, 2005.

Oakeshott, R. Ewart. *The Sword in the Age of Chivalry*. London, 1964; reprint ed.: Mineola, NY, 1996.

Paggiarino, Carlo. *The Churburg Armory*. Milan, 2006.

Rogers, Clifford J., ed. *The Military Revolution Debate: Readings on the Military Transformation of Early Modern Europe*. Boulder, CO, 1995.

Smail, Daniel Lord, Edward Muir, and Osvaldo Raggio. "Factions and Vengeance in Renaissance Italy: A Review Article." *Comparative Studies in Society and History* 38, no. 4 (1996): 781–89.

Websites

Higgins Armory Museum, Worcester, MA. A leading institution in the study of historical European martial arts. http://higgins.org.

J. Paul Getty Museum. All the images from the Museum's manuscript *Fior di battaglia* can be seen in sequence at http://www.getty.edu/art/gettyguide/artObjectDetails?artobj=1706

Mondschein, Ken. Historical Fencing. Information on historical European martial arts and links to schools worldwide. http://www.historicalfencing.org.